Go Logo!

A Handbook to the Art of Global Branding

ROCKPORT

First published in the United States of America by
Rockport Publishers, a member of
Quayside Publishing Group
100 Cummings Center
Suite 406-L
Beverly, Massachusetts 01915-6101
Telephone: (978) 282-9590
Fax: (978) 283-2742
www.rockpub.com

Library of Congress Cataloging-in-Publication Data
Cato, Mac.
 Go logo! a handbook to the art of global branding : 12 keys to creating successful global brands / Mac Cato.
 p. cm.
 ISBN-13: 978-1-59253-517-0
 ISBN-10: 1-59253-517-8
 1. Branding (Marketing) 2. Consumer behavior. 3. Identity (Psychology) 4. Emotions—Social aspects.
5. Communication in marketing. 6. Creative ability in business. I. Title. II. Title: Go logo. III. Title: Creating successful global brands. IV. Title: Global brands.
 HF5415.1255.C38 2010
 658.8'27—dc22

 2008039715

ISBN-13: 978-1-59253-517-0
ISBN-10: 1-59253-517-8

10 9 8 7 6 5 4 3 2 1

Design: Katie Warner and Sirkka Richert
Book Layout: Megan Jones Design

Printed in China

Go Logo!

A Handbook to the Art of Global Branding

BEVERLY MASSACHUSETTS

ROCKPORT PUBLISHERS

12 Keys to Creating
Successful Global Brands

Mac Cato

Contents

Introduction

Why This Book Now?

Back in the 1960s, a close friend of mine, a solidly left-brained Procter & Gamble executive, said he would love to write a book, if only he had something to write about. We both laughed. I understood what he meant. My right-brained, creative journey had just started, and I wasn't too clear about where I wanted it to go. It took another forty-odd years—some of them exceedingly odd—but my journey is complete. I've seen a lot and done a lot, and a look back is often the best way to look ahead.

Much is changing in the science of branding. But the art of branding—and the key roles that creatives and visual language play—has become even more important in bringing brands to life. The natural audience for this book includes creatives, marketing executives, and any organization seeking to stay competitive in a media-saturated world.

But branding, of both the societal and commercial persuasion varieties, plays such a major (and often controversial) role in our global and local lives today that understanding how and why it all works should interest just about everyone. Besides, there are lots of pictures.

Go Logo! A Handbook to the Art of Global Branding posits that all successful, emotionally centered brands fall into one of two general classifications: commercial persuasion branding (Coke Is It) or societal persuasion branding (any "ism" you can think of). But disciplined creativity is critical in both kinds of branding—and in the context in which all the threads of this book come together. Just how important a factor is it, actually? Is it really as critical in societal persuasion branding as it is in commercial persuasion branding? What are the personal characteristics of a successful creative brand warrior? Are good creatives born or made? And what are the key determinants that will most likely shape a successful career?

Go Logo! is also in part a memoir with stories from a lifetime—stories from growing up in a time of great historical significance and about why I believe history has shaped my career. Global brand warriors today face far more complex challenges than when I first chose my creative tools to

SAFEWAY

Safeway logo
(Design: Bright Strategic Design & Branding)

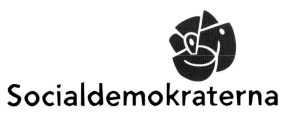

Socialdemokraterna

Swedish Socialist Party logo
(Design: Estudio Mariscal)

join the branding battles. And that is why one of my primary reasons for writing this book is to provide guidance to up-and-coming warriors.

During my half century as a brand warrior, I have been fortunate to work with many notable brands. Sometimes, it was just for one project; at other times, it was for many years. As I reflected on the assembly of this book, I concluded that there was one overarching hypothesis I could apply to all of them. Essentially, all successful branding depends on creatively appealing to the target audiences' hardwired need for personal identities. Sounds all too simple, but think about it this way: The unconscious choices we all make from a menu of branded societal and commercial belief systems constitute the emotional core of our lives—and motivate most of the actions we take.

Successful brands have to address these needs. The best ones learn how to dig down below the level of consciousness to exploit those hidden hopes and fears: "Who am I? Where and how do I fit into the society I live in?" This is as much a science as it is an art. But once the visual triggers to the consumer's subconscious desires have been identified, the brand stewards and consultants can begin to develop appropriate creative communications tools—and proprietary visual languages.

To get below the surface of consciousness, where most decisions are initially made, I propose that it is always best to observe my golden rule of branding: Understand through discipline; compel through imagination. The best brand warriors discipline their creativity to the point where they can focus like a laser beam on audiences' emotional needs.

I suggest that disciplined creativity is the one irreplaceable tool you need in your branding toolbox.

– Mac Cato

Ancient warrior helmet

Chapter 1
The Making of a Creative Brand Warrior

So, just what *is* a Creative Brand Warrior? And why choose this particular, one-size-fits-all descriptor for the very eclectic roster of experienced, highly respected contributors to this book? Well, therein lies the story, and the context, of this book. After thinking a lot about how to best capture and pass along the lessons learned during fifty years of participating in clients' global branding battles, the old title of consultant or expert seemed a bit lame. And the guru label, used facetiously or not, didn't fit at all. With such a diverse list of contributors, only the phrase "creative brand warrior" seemed to fit everyone. All included here are admired for their skills, and respected for both their past accomplishments and their continued openness to new challenges. Each has been an innovator, and each has always been willing to fight for what he or she believes in.

One other commonality among these contributors is their understanding of the importance of partnership. All know that *the* essential requirement for successfully establishing a solid brand is to create a sense of partnership with all of a brand's key constituents, including the brand stewards within the parent organization, the brand's distribution and communication channels, and, most of all, with the brand's consumers. Perhaps this was always true, but never has it been more important than today.

The *Chambers Concise Dictionary* (favored because it is exactly that, concise) partially defines "partner" as "an associate, a person engaged with another in a business, a person who plays on the same side in a game, and a person who goes in to a formal dinner with another." These definitions are quite apropos when applied in a branding context. Consumers today know that they have the upper hand in the partnering dance, with no allegiance to the partner who brought them. And the only way the marketer and the consumer are playing on the same side is when consumers consistently get what they want. In every instance, it is the buyers and not the sellers who control this particular kind of relationship.

The creative brand warriors at Lippincott successfully partnered with their clients to develop this eclectic range of global identities.

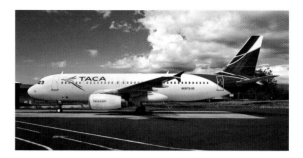

TACA, a proud Central American airline, offers services throughout Central, South, and North America with hubs in El Salvador, Panama, Costa Rica, and Peru. (Photos: Albert Vecerka/Esto)

Over time, bonds forged within creative organizations can fray badly, as the overall business changes or the interpersonal relationships begin to clash. The best creative relationships—whether in principal/subordinate roles, or in a client/agency situation—occur when mutual respect and a genuine liking for one another are a significant part of the working relationship. In a creative business, there has to be one person nominally in charge. Or, at the very least, there must be clearly outlined responsibilities for all equal partners, to ensure the firm's collective energies are harnessed together in pursuit of agreed, common goals.

Most creatives will experience working in different kinds of brand warrior tribes, including very large ones, but will gain most of their valuable experience from working

in relatively small creative firms. *Chambers* simply defines "warrior" as "a fighting man." This disposition is a prerequisite to success in creative branding. However, it's not such a good trait to share between partners in small enterprises. William Kirn wrote the following passage to open his *New York Times* Book Review piece on Robert Stone's *Prime Green*, a personal memoir of the 1960s. It captures what I feel is the most important lesson "of a creative life lived."

"Time passes, and what it passes through is people—though people believe that they are passing through time. And even, at certain euphoric moments, directing time. It's a delusion, but it's where memoirs come from, or at least the very best ones. They tell how destiny presses on desire and how desire pushes back, sometimes heroically, always

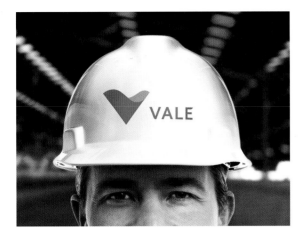

Vale, the second largest mining company in the world—and one Brazil's most admired companies—now has a unified identity to mark its commitment to social and environmental responsibilities.

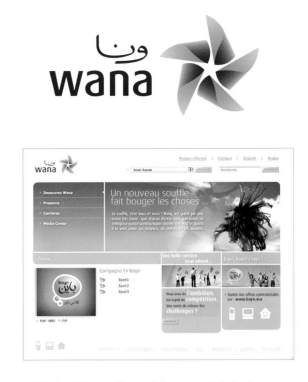

WANA is Morocco's new full-service global telecom company. The Wana symbol, a dynamic star, references the Moroccan flag and connects with the Moroccan spirit.

poignantly, but never quite victoriously. Life is an upstream, not an uphill, battle, and it results in just one story: how, and alongside whom, one used his paddle."

- What's the best way to prepare for what Kirn calls that long "upstream journey?"

- How do you first select the right paddle—and then learn how to use it really well?

- Perhaps most importantly, with whom do you hope to paddle alongside?

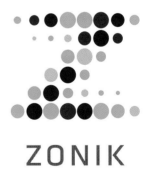

Lippincott created a new name and brand positioning strategy for what would be the hot retail destination for all technology, entertainment, and lifestyle needs of young people in Saudi Arabia. Zonik is a vibrant environment in a café format where young trend-setters come together to explore video and music downloads, gaming, computing, digital photography, and mobile telephony.

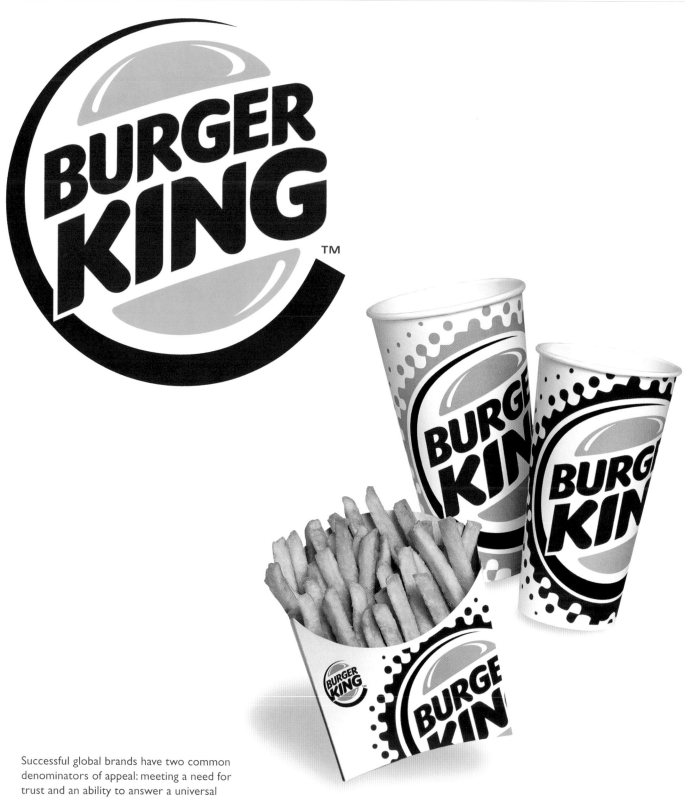

Successful global brands have two common denominators of appeal: meeting a need for trust and an ability to answer a universal need for real sustenance, whether physical or intellectual. Burger King has global recognition even when the entire logo isn't always visible. (Design: Sterling Brands)

Chapter 2
The Two Mega-Categories of Global Branding

Definitions:

GLOBAL SOCIETAL PERSUASION BRANDS:
Powerful belief systems, usually represented by highly recognizable names, icons, symbols, or stories, intended to invoke strong emotional responses and motivate commitment and action by others.

GLOBAL COMMERCIAL PERSUASION BRANDS:
Widely recognized identity systems represented by stories, intended to evoke emotional responses strong enough to consistently motivate the sale of commercial goods and services.

Most of the great global brands, of both the societal and commercial persuasion varieties, succeed because they are so emotional and personal. Branding is essentially about appealing to our need for personal identity. Who am I? Where do I fit in? How do I best target my hopes and manage my fears? The choices we make to address these psychological needs, from a menu of branded societal and commercial belief systems, constitute the core of our lives and motivate the actions we take.

Naomi Klein's *No Logo: Taking Aim at the Brand Bullies*, Eric Schlosser's *Fast Food Nation*, and Robert H. Frank's *Luxury Fever* are but three of a slew of anti-branding books published over the past few years. Their collective argument, perhaps most dramatically characterized by Klein, is that global corporations are "cocooning" us in

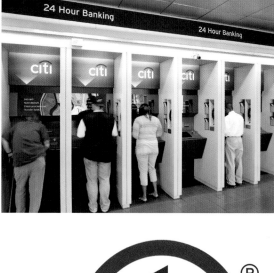

a "brandscape" and offering us a "Barbie world for adults." Books like this have had some positive impact. Most corporations today are much more sensitive to their societal responsibilities and attempt to balance their good talk with good actions.

No Logo disciples claim that brands are the pathways of manipulation between companies and consumers. But the truth is, people *like* and *need* brands. Brands, for both commercial and societal persuasion purposes, simplify choices, promise authenticity, and provide pleasure, interest, and a sense of identity. Today, it is the consumer who decides a company's fortune.

Citibank is a universally recognized bank with ATMs all over the world. (Design: Paula Scher, Pentagram; Photo: James Shanks)

A Paradigm Shift

Is the negative questioning about the importance of branding actually topical in this world of increasing global convergence? Isn't our addiction to branded goods and services a natural and generally positive factor in our lives? What does Klein say about global commercial persuasion brands that include a societal "call-to-action" in the positioning of their businesses and their corporate brand identities? British Petroleum merged with Amoco in 1998 and simply became BP. After a series of other Amoco petroleum acquisitions, the BP logo was redesigned, and the tagline for all BP products became Beyond Petroleum. General Electric, one of the

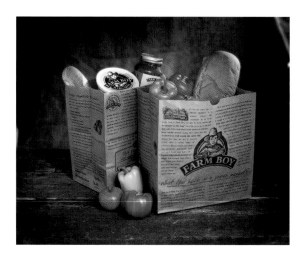

Farm Boy's striking identity demonstrates the level of graphic sophistication required to successfully compete with well-known international retail brands. (Design: Greenmelon)

Starbucks pioneered a new experiential coffee shop concept, developed a unique business concept, and created a distinctive brand identity for its global retail system. But it's much more than coffee and lattes: Starbucks has successfully created a coffee shop with a social environment experience that brings customers back time and time again. And the company's commitment to societal issues, such as its support for fair trade coffee, adds considerably to the brand's high regard in the minds of its customers. (Design: Starbucks)

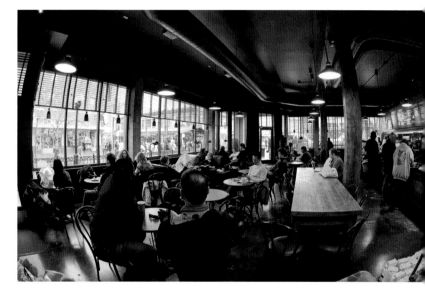

ABOVE: Xerox recently introduced a dynamic new logo and a full global identity program to signify the company's diversification into new business areas. (Design: Interbrand)

RIGHT: The design of the Ambi Pur packaging creates an aura of freshness within the bottle. (Design: DesignBridge)

The imaginative redesign of the BP brand identity strongly emphasizes the company's commitment to an energy future "beyond petroleum." (Design: Landor)

world's largest and most complex industrial giants, adopted the corporate mandate of Ecomagination and committed the business units to a greener way of doing business. Each of these companies, though recently criticized by the media, have boldly nailed their corporate missions to their mastheads and committed their companies to staying on course and moving ahead. And it's important to note that the creative brand warriors within these companies, along with their external design-consultant colleagues, have been honored for their persuasive communications programs.

So, *are* some brands as bad for us as Naomi Klein so adamantly claims?

The answer, of course, is, "it depends." Brands are now ubiquitous, and the most powerful ones are pervasive, persuasive, and very habit-forming indeed. Some brands *are* bad for us, if the products or ideas they stand for are likely to be harmful to our health, mentally or physically, when used to excess. However, branded products that offer life's little pleasures and conveniences will not be going away any time soon. They are too comforting, and they make us happier, even if only for a little while. Living

Formerly a value brand, the redesigned Suave logo and identity communicate a new sophistication to fit its repositioning. (Design: Sterling Brands)

without brands would not only be boring, it would be very bad for our financial health. Overall, the manufacturing, distribution, marketing, and sales of consumer-oriented branded products and services is "the business" that makes the world go round. Add in global B2B (business-to-business) transactions, and the sum total of the world's brand-led business transactions is immense. Without the competition generated by opposing brands, prices would go up and consumer choice would go down.

Contemporary thinking, positive and negative, recognizes the ability of brands to communicate in significant mental shorthand about the products and organizations they represent. Although some think both commercial and societal persuasion branding is exploitive, the great majority just take brands for granted. Businesses and organizations realize they can't do without them. Political parties live and die, as appeal rises and falls.

Chapter 3
The Three-Pound Universe

t's easy to see why, in the 1960s, commercial persuasion branding coexisted so well with the societal persuasion changes of the times. The refreshing, satirical mood of popular culture was all around us, vibrantly evident on stage and in fashion, music, film, television, the club scene—and even in print. Radio and television liberated the attitudes of the public far more extensively than did all the marches and slogans of protestors. The advertising community soaked it up, and the cheeky ones started their own revolution in marketing communications. The problem was that most clients had *not* changed.

We started looking for ways to help convince the more conservative clients that this new cultural, sensory language was now locked into their customers' heads, and, in turn, we needed to start creating fresh concepts for brands, packaging, and graphics. The consumer was now open to ideas that reflected the cues and codes of this cultural shift.

Fortunately, help was at hand, because there were lots of new theories from the psychiatrists, psychologists, and sociologists about what might be going on in the subconscious.

Maslow's Hierarchy

Abraham Maslow, Ph.D., studied monkeys and found there was a definite rank order in the basic needs that monkeys chose to satisfy. Thirst came first, then shelter, and only then did they look for food and companionship. When Dr. Maslow went on to study humans, he found that they acted in much the same way. These hierarchies are still a basic primer on how we rank our human needs and understand our basic motivations. Many researchers have turned these basics into lifestyle "types" to segment target audiences into different sociodemographic classes.

Brand planners use different sociodemographic profiles to match specific brands with specific audience segments. They try to focus on those consumers who theoretically demonstrate the social behavior characteristics that the brand can target with its marketing communications.

Wunderman, the merged successor to my old company, Cato Johnson, breaks these typologies into segments titled Explorers,

Aspirers, Succeeders, Reformers, Mainstream, Strugglers, and the Resigned. Other global corporations use titles such as Aspirers, Achievers, and Creatives, among others. I've consistently found that solely as stand-alone words, these evocative descriptors can be useful in stimulating the imaginations of creatives and clients in brand-planning sessions. However, these descriptions, without visual explanations, are still just words.

It is vital to note that the stereotypical images that make up the mosaics we use in our work are quite purposely drawn from film, the media, and other cultural sources that audiences have seen many times. Until a large number of subjects or activity-defining pictures or illustrations become so ubiquitous that they have taken up semipermanent residence in the memories of very large audiences, constructing these kinds of visual metaphors is impossible. In a switch on the research truism that people can't tell you what they don't know, they *can* tell you how they feel when exposed to ideas they can see. This method of creatively constructing original concepts from very familiar pieces is sometimes called "scrap art" by severely left-brained clients. This usually isn't meant as a compliment, but these carefully designed pieces do use "scraps," and sometimes the result is a work of art. Andy

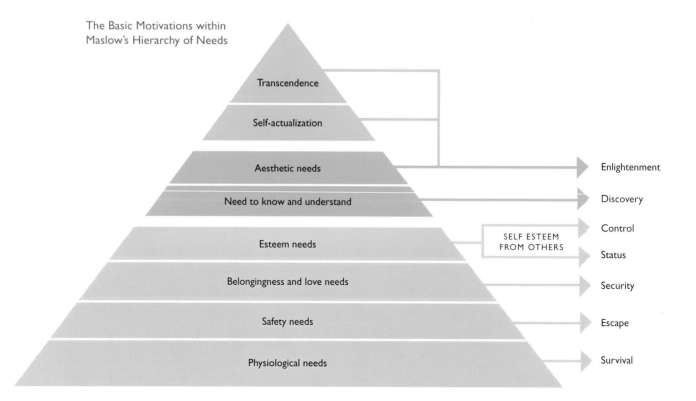

The Basic Motivations within Maslow's Hierarchy of Needs

Warhol, Tom Wesselmann, and many other fine artists probably would not have objected to this description.

It takes both the hard graft of interpreting data and a sensory exploration to develop a visual, emotional concept that communicates a brand's essential meaning to a carefully segmented audience. Of course, eras too have brand personalities, both societal and commercial, and, although brand warriors need to be skilled at "looking out" to understand the surface characteristics of a zeitgeist, the clued-in ones know they need to dig deeper to examine what is happening below the level of consciousness.

A 2002 report from Cultural Studies & Analysis in Philadelphia states, "People cannot tell you what they want or what they would do in a given set of circumstances with any reliable degree of accuracy. However, people do intuitively recognize what they want when they see it—with a high degree of accuracy." Since then, more and more neuroscientists and neuropsychologists have confirmed that, as Cultural Studies & Analysis states "over 90 percent of our decisions are made at an intuitive level, and the data the human mind uses to reach these decisions resides below the level of conscious awareness. Our human brains are the most complex in the universe, except the universe itself."

Chen Design Associates created these logo variations for Verve Coffee Roasters to use for different purposes and formats. (Design: Chen Design Associates)

Reel Centric is a digital video advertising company, as this logo aptly demonstrates. (Design: Chen Design Associates)

Hershey's is a familiar brand that has subtly changed over time, but it has retained its key brand attributes so as not to confuse—and consequently lose—consumers. (Design: Sterling Brands)

As the authors Jamie O'Boyle and Margaret King, Ph.D., remind us, "All we know about the working of the human brain has been discovered only in the past few decades, due in large part to a technical revolution in computer imaging. We can now look at the activity of living brains as a human subject reads, speaks, listens to music, looks at objects, or solves a problem." The implications of this for visual and verbal creatives are enormous. What the cognitive unconscious does, according to O'Boyle and Dr. King, includes everything from processing data to judging people, formulating stereotypes, and inferring causes, all beyond our conscious awareness. And this happens in a nanosecond. Then, and only then, the conscious process goes to work, critically classifying and weighing out the data already pre-selected below our conscious threshold.

Gerald Zaltman and his son, Lindsay H. Zaltman, in their 2008 book, *Marketing Metaphoria*, explore many of the same themes that are explained throughout this book but from a different sensory perspective. Gerald, five years earlier, wrote a book called *How Customers Think*. In this book, he argued that buying decisions are not as rational as so many brand warriors assume and that these decisions stem from unconscious and emotional thought processes. In the later book, the Zaltmans explore the specific issue of metaphors and how we use them to frame the world we live in.

They quote Steven Pinker, Harvard College Professor and Johnstone Family Professor of Psychology at Harvard University, a renowned expert on how the brain uses language: "Metaphor is so widespread in language that it's hard to find expression for abstract ideas that are not metaphoric." The Zaltmans themselves use the metaphor, "unconscious viewing lenses," to describe how we structure our thoughts and our actions. They say that "deep metaphors are enduring

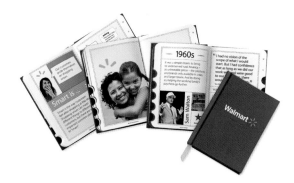

Lippincott recently redesigned Walmart's identity by creating a more human and warm logo mark, while also maintaining the core ethos of the company—providing quality service and products at a lower price point. A limited-edition, hardcover brand book explains the history and evolution of the company. (Design: Lippincott)

ways of receiving things, making sense of what we encounter, and guiding our subsequent actions . . . they are the product of an ever-evolving partnership between brain, body, and society."

The Zaltmans believe that too many marketing executives don't really understand what the marketers like to call "consumer insights." They schedule focus groups and come away believing they now understand their consumers' thinking and their values. But, in fact, the marketers usually don't know, because the consumers can't tell you what they don't know. However experienced and skilled the focus group moderator might be, the respondents will not be in touch with their subconscious feelings—unless the right visual stimuli are used. As the authors say, too often in focus groups, consumers are forced to respond to ideas that are not generated by them. Conscious questions are asked about unconscious processes.

The Zaltmans argue that brand stewards, and their creative brand warrior allies, must listen much more closely to what individual customers tell them and develop greater sensitivity to the language they use. They believe that consumers intuitively "get" a metaphoric point about connection, and understand, in a pleasurable way, how the product can help them make connections. The Budweiser commercials of a few years ago, shown in the United States and in the United Kingdom, were very memorable. For weeks, we had young men yelling "Whassup!" to each other, cleverly making a profound point about connections and how the product can help form them. Connection has successfully been used by many brands for many years, but it is usually only the cleverest ones that actually help push sales. The Zaltmans say that other important metaphors—balance, transformation, container, resource and control, along with journey and connection—are factors in about 70 percent of customer thinking.

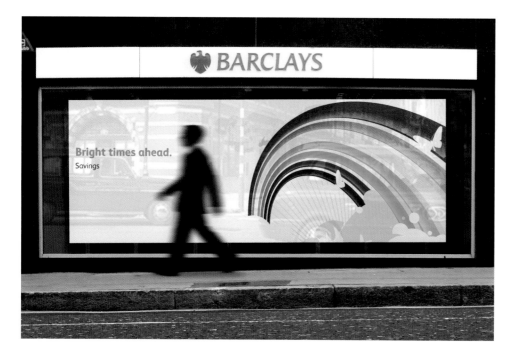

ABOVE: This advertisement for Barclays clearly communicates the brand and interacts with London viewers in that the city itself is reflected in the ad. (Design: Interbrand)

RIGHT: Banks wishing to develop customer-oriented environments, to provide customers more pleasurable brand experiences, should consider the many successful examples of coffee destinations such as Cubby's. (Design: Evenson Design Group)

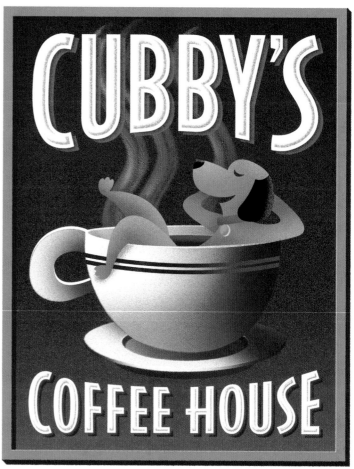

Creating Ideas They Can See, Hear, and Feel

The human brain is the most complex system on Earth, and its interwoven nerve cells control our activities and our choices. Ongoing brain research has led to breakthrough collaborations in neurology and physiology, biochemistry and medicine, cognitive science and psychology, computer science, artificial intelligence, and genetics. All of this new knowledge can and should change the art and science of both commercial and societal persuasion branding. Science is literally getting an inside look into the black box of the brain to see exactly "how we sense, process, learn, ignore, remember, forget, feel, value, and decide," according to Cultural Studies & Analysis.

Most creative brand warriors are not scientists. It's logical for creatives to follow a step-by-step methodology in searching for the type of breakthrough ideas that can anchor a complex brand-communications program. Many creatives distain the idea of a process, believing that this only stifles the imagination. For a few design geniuses, perhaps this is true, but, unlike most artists, writers, composers, and others who work alone, creative brand warriors have little choice: They need a process to facilitate working in teams. For instance, it's widely assumed that the client is always in charge of the team, making it a given that a methodology is required to keep everyone in the same boat and on course.

Marketing clients have been strongly biased toward the importance of conscious, "rational" thought over "emotion," which is still viewed by many as being unreliable. It is imperative that creatives help clients understand the ramifications of the fact that we *all* use our cognitive unconscious to make amazing decisions. We've long accepted that, for branded products and services, we don't just buy features, we buy into values. We must also remember that values are simply broad tendencies of preference for one state of affairs over another. Times change and values evolve; our human brains are meaning-seeking devices. Dr. King and O'Boyle describe our cognitive unconscious as a "rigid-image description system that transforms transient sensory events into a world of perceptual objects." Our constantly evolving need for branded products, services, and ideas validates who we are, how we got here, and what is expected of us. These values are communicated, over time, through societies' popular cultures. We all make our choices in the ways that count the most—with our time, our money, and our votes. We are social primates, and we unconsciously compare ourselves to others for validation and consensus of the norm.

Skin, Skeleton, and Spirit: Layers of Design

SOOSHIN CHOI, *Professor and Head of Industrial Design at the College of Design, Art and Planning (DAAP), University of Cincinnati*

Sooshin Choi became an automotive designer when he was twenty-two years old and developed more than ten automobiles over eighteen years. He continued his career as a design director in the furniture field to develop a number of system furniture designs. Most of his designs are remembered as bestsellers. He founded the industrial design group at DEKA Research and Development Corporation and contributed to the designs of innovative products such as iBOT and Segue. Since 2003, he has been teaching future designers as a professor and head of the industrial design program at the University of Cincinnati.

Layer One: Beauty is only skin deep, but it is deep.

We've all heard the saying, "Beauty is only skin deep." And yes, this is true. However, the skin is composed of many layers, and it is much more complex than it appears on the surface. The skin is more than just a part of our appearance; it protects the body from impact, temperature, moisture, and dehydration. In a sense, skin is the most vital part of our body; it keeps us alive.

When I was an automotive designer at Daewoo Motors (1978 to 1986) and Kia Motors (1986 to 1995), my interest was not only in the style of the vehicle but also in enhancing the purpose of the vehicle through its style. As a designer, I assumed my role was to search for a style that served the purpose of the vehicle and to find aesthetics that people would consider beautiful. One example is the Kia Sephia (designed and developed between 1988 and 1992 and launched in 1992), which set a new standard for a subcompact family car in Korea. There were two challenges in determining the design direction: First, Koreans liked things that appeared larger than their actual size; and second, the competitive models at the time were excessively adorned with chrome-plated trims and decorations. In essence, the first challenge was to deal with the traditional perception of beauty, and the second challenge was to deal with the contemporary comprehension of beauty.

Sephia automobile rendering

I didn't think either one should be a contributing factor in the design process. For me, the key objective was to develop a design that was in complete harmony with the purpose: to develop a subcompact vehicle for personal and family use—not a flashy car with meaningless chrome.

Sephia rendering

Layer Two: A skeleton looks eerie, but without it, the body would look even more eerie

Just as it is important for us to understand our anatomy, it is important in design to know the context in which the things are going to be used. After eighteen years of designing automobiles at Daewoo and Kia Motors, I moved to Fursys, a leading system furniture manufacturer, where I led the design development group as the director of research and development. To design system furniture for office environments, one needs to know more than just furniture. A lot of furniture designers tend to focus on the design and the manufacturing aspect of the furniture; they calculate the cost of materials and production in search of effective design. Other designers focus on aesthetics to make furniture more beautiful and more marketable.

However, the key element to designing furniture lies in looking at different lifestyles and work environments. Often, it is about observing the work processes, team structure, and information flow and understanding the transition between work and leisure time in the office. The heart of the matter is to determine the best way for furniture design to support the culture and environment of the office. This is the Fursys design group's top priority. This goal is embedded in the company's motto: creating *vital work space*. Fursys designers do not speak of furniture alone. Theirs is a genuine interest in supporting the whole work environment, in contrast to competitors, who describe their products as space-management office furniture or friendly office furniture.

Furniture system

Although Fursys is not an interior design firm, the company has a similar sensibility in designing and producing furniture. For a design director, the priority is to create value by seeing the context of the environment as an ideal scenario—and then designing furniture that enables the story. In the pursuit of value, the solution often surfaces through the process of first understanding the subconscious needs and wants of the users. The Prego stacking chair is an excellent example of this methodology.

(continued on page 28)

Designed in conjunction with professor Reinhart Butter at The Ohio State University, Prego was designed to be the most efficient chair in stacking as well as comfortable in seating. While this might not sound like a groundbreaking goal, the fact is that stacking chairs are usually neither efficient as stackables, nor are they comfortable. Many chairs that are comfortable are not efficient, because they are too heavy to manage.

Layer Three: The skeleton is covered with skin

Many designers know how to make things look good and work well, but only a few can breath *life* into products. Design is more than form and function; it needs the designer's "breath of life." An industrial designer's main goal is to develop the most ideal design for a product and, at the same time, maintain a mindset that focuses on *people*. In a corporate structure, designers are often the primary spokespersons for consumers. The bridging of beautiful form and useful function is relatively easy, compared to really understanding the needs of those who will eventually use the product. Loving and caring for people can and should be the "breath of life" that makes a design more than just a good design.

When I was working on iBOT, the inventor, Dean Kamen, refrained from calling it a wheelchair. Our dream was to help people with mobility impairment live more independently. The technology, invented and developed by Kamen and the team, enables the user to go anywhere without help from others. Its Balance Function lets the rider reach the top of a shelf or talk to someone without having to bend his or her neck. In its 4-Wheel Function, the rider can travel over any terrain. In the Stair Function, the user can climb stairs alone, and, in the Standard Function, it becomes an ordinary wheelchair.

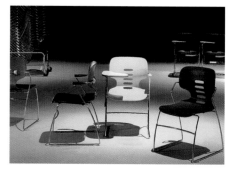

Prego chairs: The thin metal frame and seat pan make the chair extremely lightweight, and its ingenious structure provides exceptional comfort in the sliding/reclining movement. The result is a lightweight *and* comfortable stacking chair.

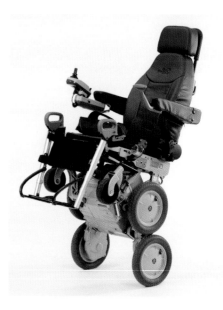

iBOT was the result of designers and engineers putting all their knowledge into the development of a product that provides freedom to people who need it most.

What Lies Beneath, and How Do We Get There?

The alluring, sophisticated ads in *Vogue* and *Elle* mirror the class aspirations of hundreds of thousands of avid voyeurs—but rarely their actual purchasing patterns. Many New York women walk into the famous retail emporiums on Fifth Avenue, look around, and walk out without a shopping bag sporting a famous logo. They then head to their favorite discount outlet to look for the same labels at a fraction of the department store price. Their "creed" is to be seen to be fashionable, but their assumption is "I can get it wholesale."

Another example of contradiction is amusingly apparent in the way we look at automobile advertising. We often talk a good game about the importance of comparison shopping, checking the expert rankings on style, safety, and value, and then choose the one we "like" the best. For big-ticket items such as automobiles, the costly commercials (which the manufacturers mostly pay for) are not primarily intended to sell to new

consumers but to validate the decision of those who have already bought the product. Because the brand exists in the consumer's mind, not in the product itself, consistent validation is a key element of brand management.

Douglas Hofstadter, Ph.D., a professor of cognitive science at Indiana University, is the author of a number of acclaimed books about the mysteries of our minds. He is also a great believer in concocting analogies to help us comprehend how the mind works.

In his book *I Am a Strange Loop*, Dr. Hofstadter firmly states that we think by seeking and drawing parallels to things we know from our past. He says, "We therefore communicate best when we exploit examples and metaphors galore, when we avoid abstract generalities, when we use very down-to-earth, concrete, and simple language, and when we talk directly to our own experiences." Twist this slightly and

Unravelling the DNA of a MasterBrand

"Looking in"
Psychological audits of the cultural myths, personal values, and "age stage" rituals most likely to conceptually represent the lifestyle of a target audience and its needs now— and in the future.

Identifying the key visual experiences a target audience has experienced over time, balanced with an analysis of the most likely cues and codes linked to the emotional likes and dislikes that lie beneath the level of their consciousness, can guide the development of a proprietary visual language for a brand.

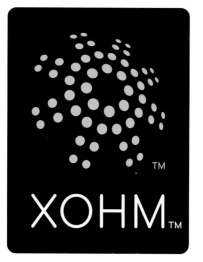

The brand identity and environmental signage for XOHM, Sprint's WiMAX wireless network, features a simple, bold pattern design representing communications through a graphic dot language. The environmental graphics were on display at the Consumer Electronics Association's 2008 trade show in Las Vegas. (Design: Lippincott; Photo: ©Peter Aaron/Esto)

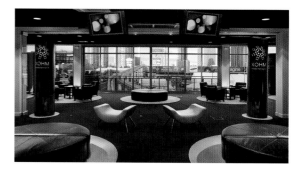

substitute "our consumers'" for "our own," and we have a precise coda for brand warriors to follow. Can you recall, off hand, any commercial persuasion call to action more simple, concise, and yet powerful as Nike's "Just Do It" Or GE's old tagline, "We bring good things to life." Or Hellmann's mayonnaise tagline, "Bring out the best." These metaphors are emotional and easy to understand.

On the societal persuasion front, there have been many resounding calls to action that are branded by repetition. In the early days of communism, the imperative slogan of Marx's and Lenin's "Workers Unite! You have

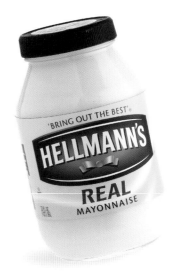

The updated Hellmann's logo is carried through all its products. (Design: Sterling Brands)

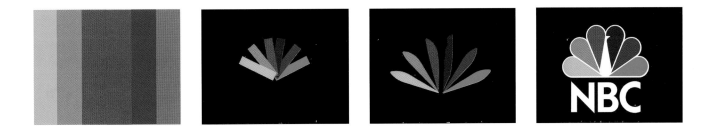

This animation concept depicts the color bars used for tuning television monitors, which then mutate into the NBC peacock logo. (Design: Steff Geisbuhler, Partner, Chermayeff & Geismar Inc.)

nothing to lose but your chains!" must have been electrifying to the masses (and terrifying to the bosses). Christian fundamentalists often post signs along roadsides declaring a simple truth, as they perceive it—"Jesus Saves." And, of course, most global religions, as *isms*, long ago settled on universally understood logos designed to act as powerful symbols for their belief systems.

Dr. Hofstadter has another way of explaining the what, why, and how of the way we perceive ideas. "Human brains are constantly trying to reduce the complexity of what they perceive, and this means that they are constantly trying to get unfamiliar, complex *patterns*, made of many symbols that have been freshly activated in concert, to trigger just *one* familiar pre-existing symbol...The main business of human brains is to take a complex situation and to put one's finger on *what matters* in it. To distill from a welter of sensations and ideas what a situation is all about. *To spot the gist.*"

And that is close to what creatives are trained to do. Of course, the "spotting" part must come first. The best brand warriors realize they must begin by exploring the complexities of what *probably* lies beneath a target audience's motivation to respond to a design or a brand message. Then it's their task to create the gist, a sensory concept that sends out the right signals. The gist is the key message, and developing it should come last. Sure, I know we often work backward. With a flash of intuition, we conjure a fresh idea. But it needs time to ripen, to be examined carefully, to judge whether the framing idea can communicate the value of the product's tangible attributes through the alchemy of a fresh creative execution.

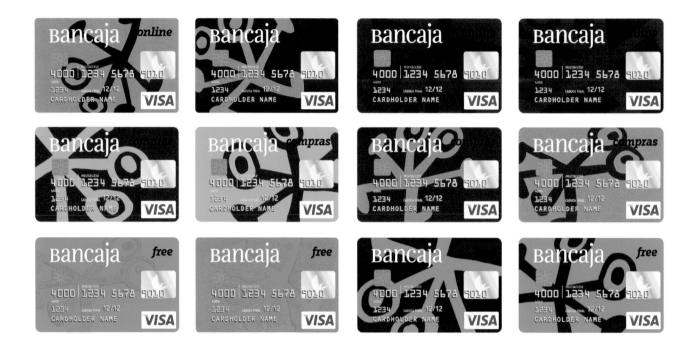

 fondos

 habitat

 viajes

This playful brand for Banjaca bank in Spain, is quite different from most financial institution logos that are quite conservative. The symbol, which is derived from an asterisk, represents transparent communication in the banking arena. (Design: Estudio Mariscal)

Banking from the Inside Out

The Mashreq bank branch designed by Lippincott is based on the concept of opening the way to retail banking. This concept is brought to life through a more contemporary look and feel, easy access to services, and a fully developed design language that feels inviting and friendly to customers. The development of these elements was directly related to the new Mashreq brand strategy and corporate identity. The resulting design is a flexible concept that can be adapted and implemented in future locations.

Consulting offices are without doors, and walls contain a blue sky graphic to convey the idea of limitless dreams. Teller counters bear no glass division between customers and staff to provide a more collaborative experience. The Retail Unit functions as both a delivery system for marketing and brand messages, as well as a distribution center for pamphlets and educational information. Additionally, these fixtures play an architectural role by working as a threshold between the waiting area and the consultation offices. The branch is fully visible from the outside, increasing the perception of brightness and vitality.

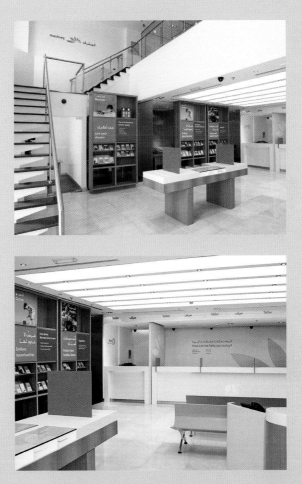

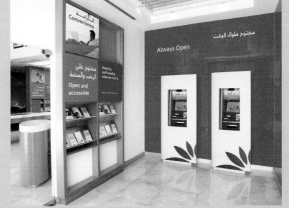

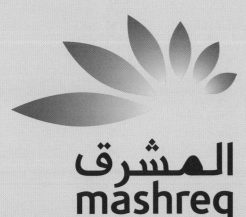

المشرق
mashreq

Retail Banking

GERRY POSTLETHWAITE, *Former Principal at Cato Johnson and Former Y&R Board Director*

Gerry Postlethwaite has been a marketing executive for more than forty years, working for companies such as Cato Johnson, Y&R, KLP Group, and RPA. Clients have included DuPont, Singer, Procter & Gamble, Philip Morris, and many supermarkets and banks in Europe and the Middle East.

Some banking genius, sometime in the late '80s, decided that the word "retail," when used to describe consumer banking, meant that countless thousands of financial-services establishments had to look and act like other types of retailers that sold clothes, food, and other commodities. This was very good news for the retail design industry, because large budgets were doled out to achieve this goal. Having attended count-less banking conferences during the late 1980s through the '90s, I was in a good position to understand why the preoccupation took root and flourished. At every conference, some banker would speak about how general retailers communicate customer appeal in their stores and how he applied the same principles to his branch designs. Where it all went wrong was that the retail banking pundits failed to differentiate between retail principles (the shopping experience) and conceptual implementation (getting it right for what you are selling).

Prior to the 1980s, branch layout and design, largely speaking, evolved, rather than went through quantum change. The space was the responsibility of the premises department, which zealously guarded its domains and its budgets against the marketing department, which was just supposed to provide the leaflets and posters.

Fast forward to 2004/2005, when Mac Cato and I linked our skills on behalf of one of the UK's largest bank networks. A new marketing guy had just been hired and discovered, to his horror, the latest "retail" prototypes opened by his new employer. Some misguided soul at the branch, working with one of the largest retail design consultants in the United Kingdom, had clearly taken the retail concept a little too literally.

The body of the branch was filled with supermarket-style gondolas with product literature in cans on the shelves. Other products were bubble packed and hanging from gondola ends and wall racks. The quick transaction zone (cash counter and ATMs) was located at the *back* of the space. The private consulting spaces (four to five semi-enclosed spaces) were located next to the waiting area, thus eliminating any hope of the all-important audio privacy. All the staff we interviewed were critical and had not been consulted. When asked to discuss product merchandising (a core ingredient of retail operations), they were simply confused.

The new marketing guy stopped any further rollout of the concept and gave us the assignment of bringing retail understanding to his senior management. The objective was to do this in such a way that they would be able to more easily interpret the guiding principles of best-in-class retailers and apply them to their own product, services category, and customer base. We visited forty to fifty top retailers in the United Kingdom, United States, and France and photographed the principle elements that made them stand out, then interpreted key elements to show how they could be applied to a customer journey in financial outlets.

We personally escorted six senior banking executives to visit selected stores and arranged discussions with senior personnel from the retailers. Finally, at the practical end of our assignment, we showed them how retailers use value-engineering principles to enable different fit-out techniques to give flexible speed and cost to space equations.

Unfortunately, there is no "right" solution that can be applied across the board.

Dealing with a customer's finances is a private issue; the relationship between a banker and a customer is similar to that between the customer and his or her doctor or lawyer. A bank's customers want a quick solution to instant needs (cash) and an expert and private solution to more considered needs. The former can be delivered in public via ATMs and service counters, such as those in most retailing, but the latter requires varying degrees of privacy and a carefully considered approach. In purely practical terms, both must be delivered within a single retail space. In addition to ATMs, the key to customer satisfaction is staff location and approachability. Most retailers will agree with this requirement but few need to be so precise in the detail because staff are a bank's products.

Making Sense of S.E.N.S.E. for Creative Brand Warriors

The full name for the S.E.N.S.E. process is Sensory Exploration/Need State Evaluation. These two simple phrases capture the essence of its purpose. (A partial case history follows the verbal explanations and charts.) Both the Sensory Exploration study and the Need State Evaluation step (these are basically self-explanatory) tackle the "what lies beneath" issues. These analyses seek to establish a hierarchy of the most important emotional connections that a target audience has with the brand. This requires a strategic and visual analysis of those issues and concerns that are most likely to be of prime importance to a predetermined consumer audience. These concerns or interests are likely to center around the established patterns of their lives and their personal views on what is appropriate in matters of style.

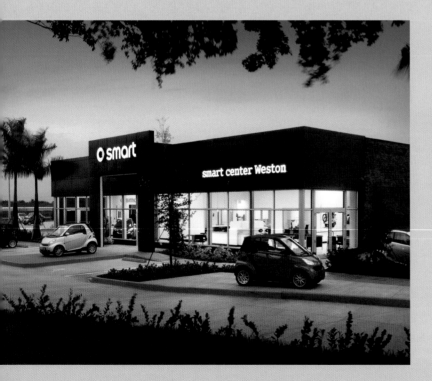

The basic phases of a S.E.N.S.E. methodology are:

Foresight: Provides a valued-added audit of the brand in a market context, analyzes the impact of major societal trends, and produces the initial hypotheses for repositioning the brand.

Insight: Examines the brand's history and legacy and ponders its future prospects. This translates to "What was it, what is it, what could it be?"

Looking Out: Often done simultaneously with foresight, especially if the project is multicultural and global. In format, it is usually based on Internet research and in-store, on-site photography, plus an extensive media survey. The purpose is to gather the widest picture possible (and practical) of the visual, sensory evidence of what the target audience sees and experiences in their preferred cultural environment.

Looking In: A creative/strategic phase, intended to sort the evidence gathered in Looking Out and create a series of sensory Cues & Codes portraits. These are primarily visual boards, carefully designed to evoke an emotional feeling, as opposed to a literal reading of separate images. Note: This is a skill requiring experience and critical judgment, in addition to a creative imagination. All creative brand warriors can acquire the required skills, but the process most assuredly takes a lot of practice and trial and error.

Convergence: Adding up the facts, observations, interviews, visual/sensory analyses, and intuitions. All are constituents that compete for primacy in drafting the initial hypothesis.

The Hypothesis: The art and science of blending and connecting the assumptions and facts to establish the criteria for action.

⊙ smart®

Inspiration: What all creative warriors live for. Based on the exploratory work of the initial phases, the team constructs a new, or adapts an existing, brand personality and further develops the brand's core essence and its key values. The creative team then develops new concepts and new brand-identity elements, including a proprietary visual/sensory brand language. These are then applied to preliminary creative executions of key communication elements, including packaging, if appropriate.

It is at this point that innovative consumer research is best used and when the Cues & Codes insights portraits are so invaluable. In focus groups and one-on-one research (remember that people can't tell you about what they don't know), it is the emotional messages emanating from the visual S.E.N.S.E. boards that succeed in stimulating the consumer's unconscious. The resulting responses should provide tangible knowledge and creative clues for the brand teams; these responses also provide the nucleus of management presentations.

Implementation happens when the external brand warrior team develops a Total Brand Domain Strategy (TBDS) guidelines program. It will then most likely be the client's job to further test, plan, and execute the program.

Included in the consultant's final recommendations might be the guidelines for new product development, brand diversification concepts, retail innovations, brand architecture standards, and concepts for promotions, events, and Consumer Relationship Management (CRM). Almost as important as the plan for external communication is an internal communications plan designed to stimulate buy-in and enthusiasm from all employees.

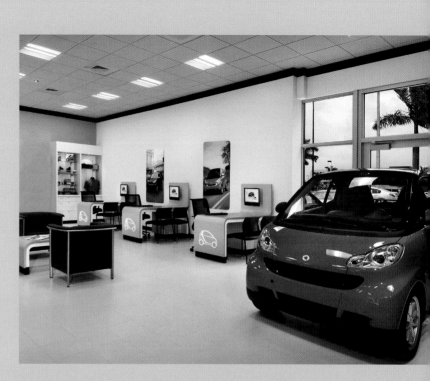

All attributes of the unique smart car were considered when developing its brand personality—from the smart logo to the consumer's experience at the dealerships. (Design: Interbrand)

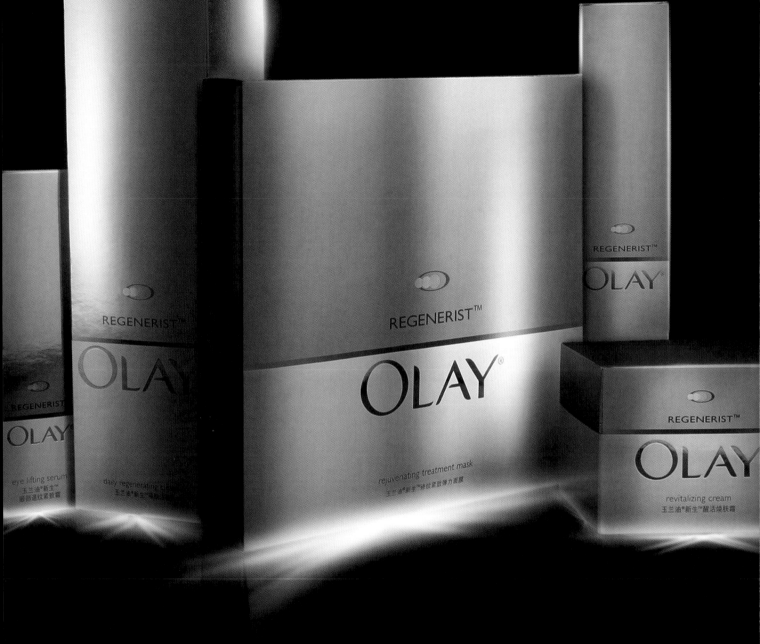

Mythmaking is not niche marketing. Olay is successful in world markets because the brand taps into ancient global myths about ways of preserving and enhancing the beauty of the female face. (Design: LPK)

Chapter 4

The Power of Myths and Archetypes

Many years ago, Marshall McLuhan, an often quoted 1960s societal behavioral philosopher, coined the phrase "the medium is the message." One could immediately guess that this phrase was going to become a staple in many learned discussions about our changing times. The essence was easy enough to grasp; McLuhan was stating as a practical fact that technology, not what we do with it, alters our culture, society, relations, and dialogues. The technologies of communications cause change in our societies, regardless of their content or how individuals think about them and use them.

Was he right? Absolutely. Television itself was pretty simple; you bought one, turned it on, and watched whatever was available. But electronic media today is not simple. Its uses are complex, they change rapidly, and no one is sure just how much our societies are affected as a result.

My branch of the creative global warrior tribe doesn't worry about this anymore. We believe that the medium is just the messenger; the *messages* are still the point. Of course, as noted earlier in this book, the definition of what content *is* has changed dramatically. YouTube and MySpace are examples of how accurate McLuhan's prediction has proven to be.

But the creative brand warrior's task is generally not to just create new major content (films or folk operas, for example), but to persuade others to buy a client's wares or buy into a societal persuasion cause. And the proliferation of message delivery systems is almost irrelevant; a good, inventive selling proposition will work across any medium. Capturing the magic is what still counts with clients—if it works in the marketplace. The branding goal should always be the creative adaptation of a timeless story, the capture of the essence of a universal myth, or the clever use of the archetypes that lie at the center of all longing and belonging brands.

The Disney event calendar is a reminder of the good times at Walt Disney World. (Design: AdamsMorioka)

The familiar over-the-top logo of the 20th Century Fox movie studios has been simplified and cleverly redesigned for Fox television and cable usage. (Design: Bright Strategic Design & Branding)

Essentially, a myth is human action that has been transformed into a story, or, to say it another way, it's the verbalization of human action. For designers and other visually oriented creatives, the challenge is to visually dramatize the verbal story into new formats, without straying from the defining myth.

Chanel has developed many ad campaigns over the years, but it's the spirit and the mystique of Paris, along with the mythical story of the founder's life, that has allowed the brand to diversify and keep the allure of Chanel very much alive. The Disney brand also lives on in the imaginations of millions of global citizens. The brand has traveled a long way from the mouse with big ears, but its continuing association with animated stories, thrilling but ultimately safe adventures, and childhood innocence ensures that the cognitive unconscious of generations of families holds nothing but positive images about the brand. Rarely, if ever, has a brand extension into three-dimensional form been more successful. There are many imitators, but only one Walt Disney World experience.

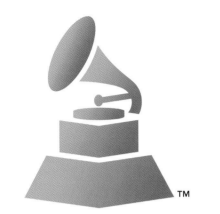

GRAMMY®

Winning a Grammy is the top music industry award and a global acknowledgement of both a performer's talent and dedication. (Design: Bright Strategic Design & Branding)

One test of the emotional strength of a brand myth is its ability to stretch, allowing successful line extensions. The most powerful myths can, both in theory and as measured in consumer research, be retranslated and applied to an amazingly wide spectrum of products.

Consumers live in an increasingly media-dominated culture. A high proportion of perceptual life is conducted through media, rather than through direct experience. The categories and frames of reference with

which people organize their thoughts follow the model provided by the media. The result is that ideas and perceptions are stored in the memory by association linkages. The more links to associated ideas a thought or fact has, the easier it is to retain and recall.

Brands that have successfully linked their brand essence with a powerful myth must be disciplined about staying with what got them there. The complete commercial persuasion communications arsenal—ads, promotions, events, CRM, graphics, merchandising, packaging—can evolve to match a changing consumer cultural environment. But the brand warriors in charge must remain true to the mythical core essence and develop associated, mutually supporting images. The iconic Coke brand has proven, despite serious miscalculations by the company's top management about the consumer's changing tastes and lifestyle "wants," that evolution does not have to be dull.

Clued-in brand warriors search for the defining myth before adding their own flourishes. On page 43 is a chart I've used when working on several very successful brands. You might want to try the process and see if it works for you.

Marlboro, the Brand

If you're a true-blue creative brand warrior, the following brand story is a sad one. More than twenty years ago, Philip Morris made Cato Gobé an offer we couldn't refuse. We were charged with exploring the full brand equity of the Marlboro brand. However, the study was *not* about the tobacco product; our job was to find out what else the brand could be.

We started by analyzing existing research about what kinds of products or services consumers, both smokers and nonsmokers, would consider buying under the Marlboro brand umbrella. The research was essentially verbal and therefore the "would try" list was short. Remember, people can't tell you what they don't know. Hats, boots, apparel, ropes, and saddles did well. But, when the list got to coffee, the rejection was almost unanimous— and so it went with the rest of the logical list.

Using the S.E.N.S.E. methodology, we designed visual boards to give us a historical mosaic of the real and mythical history of the American West. We found no shortage of heroic archetypes, from the movies of John Wayne and Robert Redford to the more somber tales of the pioneers and early settlers.

Trail Blend Coffee was developed to test a new product brand extension concept outside the tobacco category. (Design: Cato Gobé)

We explored the lands and mountains of the real West, conducted personal interviews with current ranchers, and did extensive research in Western museums. We had regular meetings with a core group of executives assigned to monitor, but not censor, our progress. We worked in discreet, agreed phases, allowing the client to end the program if not satisfied with our step-by-step observations and initial conclusions.

It was comparatively easy to construct a compelling, visual panorama of the mythical and the real. Our next big step was to develop a new, verbal, non product-oriented brand personality, working completely apart from the tobacco brand's powerful (and protective) management group. Although we could be thrown out at any time, we were developing a fresh pathway, and our project minders were intrigued.

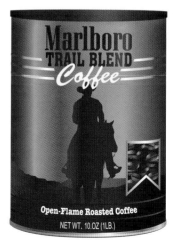

What follows is our final brand statement, the hypothesis we followed in exploring brand extension possibilities thereafter.

"The image and myth of the American West personifies the questioning and the confirmation of values absorbed throughout childhood. The myth succeeds in capturing the powerful stability of a strong, simple set of values, while simultaneously granting permission to act on the rebellious spirit of freedom and escape, expressed when we take a break from the complexities and realities of everyday life."

Next, we put the values and personality boards into one-on-one consumer research, again with smokers and non-smokers, in the United States and selected markets in Europe. The mosaic style of the visual

	ANCIENT MYTHS AND LEGENDS	"DONOR" MYTHS (MYTHS INTERPRETED INTO COMMONLY HELD TRUTHS)	NATURAL YEARNINGS IT'S TAPPING INTO	HOPES—NOT FEARS—IT'S PROMOTING	EMOTIONAL MILESTONES AND MEMORIES IT'S LINKED TO	EXISTING EQUITIES AND FAMILIAR ASSOCIATION	SET OF SYMBOLS
COCA-COLA	Man's natural optimism and his spiritedness	The free spirit of America	To enjoy yourself and to belong to the emerging global culture	We can take a break, have fun, and relax.	Good times and enjoying company	The American "backyard"	Red, distinctive logo and bottle, the "wave," "The Real Thing," and upbeat people
MERCEDES-BENZ	Man's desire to harness power	German engineers' prowess and superior quality	To be a winner, feel power, and take control	We can own the best and be recognized for it.	Graduation to achiever: I can afford this.	Famous model numbers, e.g. 450SL, German-ness, and expensive	Distinctive logo, signature grill, and masculine stature
MARLBORO	Man's need to conquer and explore	The American West and the frontier	To escape, be independent, and break loose	We can do our own thing.	Early identification with childhood heroes: cowboys, "good guys"	The lone conqueror, man amongst the elements, and the West	Red roof on pack, big sky country, and cowboys and their gear
DISNEY	Man living happily ever after and the idea that it all works out in the end	The innocence of childhood and the magic of Hollywood	To delight in good, clean fun	We can recapture happy childhood memories and relive them through our children.	Fond memories of childhood, comfort, and safety	Animation and warm, fuzzy, friendly characters	Mickey Mouse ears, Sleeping Beauty Castle, Tinker Bell, and the wand

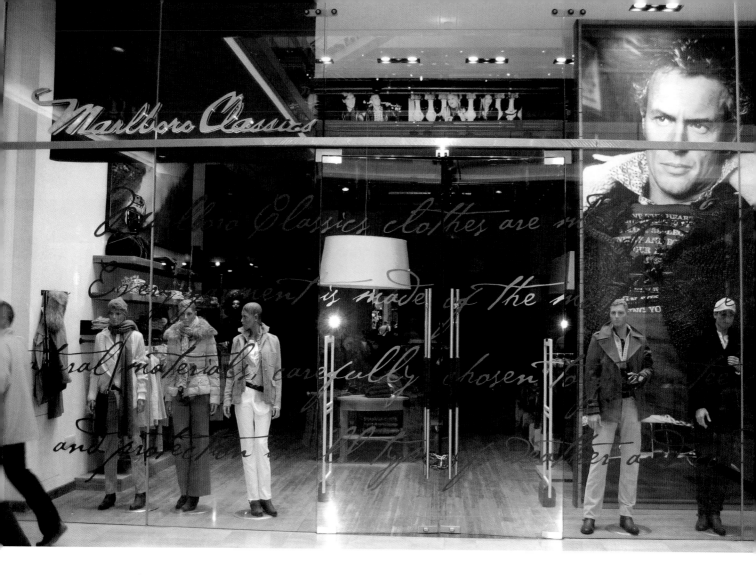

boards allowed the respondents to "read" the cumulative imagery via their cognitive unconscious. All had been informed that the investigation was not about the tobacco product; we told them we wanted their imaginative reading, positive and negative, of the projected Marlboro brand essence. The overall responses were quite positive; the values most often attributed to this version of Marlboro were individualistic, self-controlled/strong/driven, a master of nature, born leader, athletic, and a winner—the essence of an idealized modern warrior.

When *asked* if they would buy a Marlboro coffee, consumers responded along the lines of "Why would I want a coffee that tastes like cigarettes?" Very logical. But those who were *shown* a mock-up of a label that featured a beautiful, close-up photograph of a cowboy coming down a mountain trail, sun at his back, responded quite differently. At the top of the label, we had placed a small Marlboro logo; below it was a prominent brand name: "Trail Blend Coffee." Near the bottom was a small photo of coffee beans and the copy "Open Flame Roasted."

Marlboro Classics retail store front
(Photo: Cato Associates)

The response was not surprising—most coffee drinkers loved the concept. Their subconscious responded to the image of the lone conqueror in a dramatic setting and was balanced by their positive evaluation of the product claims, "Trail Blend" and "Open Flame Roasted." General Foods, which was then recently acquired by Philip Morris, commissioned extensive store tests with new product, packed in cans with our design. Again, the positive consumer research results were not surprising. There were plenty of coffee drinkers who would buy this Marlboro brand extension.

Meanwhile, we had made our recommendation. We believed that the best strategy for generating real excitement from the consumer and, of course, from traditional retailers (where the plan was to eventually introduce a number of eclectic branded products) was to design and operate a dramatic, freestanding retail concept, a Marlboro Trading Post. Marlboro Trading, as the name evolved, would be developed as a lifestyle destination, with a western bar and grill, a corner for fresh coffee, a range of apparel and accessories for men and women, a book store, and a travel bureau, where customers could book their adventure holidays.

We designed and mocked up a dramatic store/destination concept. Philip Morris hired top retail consultants, and, after many presentations and meetings with retailers, various levels of PM management, the ad agency, and lots of lawyers (of course), our small PM-managed team was prepared to move toward a Marlboro Trading launch plan.

Then there was a management change at the top, the project was killed, and there was no possibility of appeal. The real loss was the chance to prove how valuable the holistic brand is, because the indications were that many products could prosper under the umbrella of the powerful brand myth.

Ironically, twenty years ago, what was then a Philip Morris division in Europe went ahead and approved a licensed retail version of the concept, named Marlboro Classics. Today, brand licensed stores, with a more limited product scope than the one we envisioned are still in business in many countries.

Reclaiming Cultural Heritage through the Commercial World

VIRGINIE DERCOURT, PH.D., *Professor/Lecturer/Writer on Multicultural Branding Issues*

Virginie Dercourt started her professional career at Cato Gobé working as a marketing strategist for such brands as Pepsi, Gillette, Marlboro, and The Limited. She then worked for seven years as a marketing manager for L'Oréal in Paris.

Managerial and academic researchers now accept that products, brands, and points of sale in the commercial world can play a significant role in the construction of an individual's sense of self. Borrowing from psychology, psychiatry, anthropology, and history, researchers show that "materiality" plays a key role in the achievement of satisfactory lives. Marketing managers understand that they must create *ideas* consumers can see, endorse, and use to build this sense of self, but the way to do it is far from obvious. In their development of brands, products, and points of sale, marketing managers must consider all types of consumer needs and desires, which is challenging because consumers cannot always articulate how they would like things to be.

I was fortunate to experience different cultural environments—and was exposed to a lot of misconceptions about the French, the British, the Americans, the Swiss, and the Dutch. Although these misconceptions were not unusual, our essential task for clients was to discover the key cross-cultural values that these consumers *did* have in common—and to develop communications that touched these deeply felt emotional need states. At L'Oréal, my daily challenge was to manage both the emotional and the business dimensions of brands. Despite the sheer size of the group, L'Oréal as a company has managed to maintain a very strong creative culture. Regular fieldwork is compulsory, and training in different creative

CONGO

areas is held yearly. During my seven years with the group, I was exposed to very different business challenges: new product launches, distribution network issues, and international brand development.

Among my different field experiences, the ones conducted in the sometimes-troubled Paris suburban areas, among French ethnic consumers, best illustrate this ongoing challenge. As a professor teaching marketing in that area, I was surprised by the way the female ethnic students (born and raised here) use cosmetics and fashion brands. They mix and match elements of their original culture (such as the veil, the use of henna) with elements from the national culture in a very creative and personal manner. Instead of completely endorsing the French commercial culture, they seemed particularly keen to include elements of their traditional culture.

Ethnic products and brands are a booming market in a number of European countries. In France, Halal food represents a US $4.3 billion market (US $21.8 billion in Europe) and has been growing at 15 percent per year since 1990. In the cosmetic category, the Afro-French female consumer spends, on average, seven times more on hair care products than the French Caucasian. In Italy, the ethnic market represents a US$45 billion market. Not surprisingly, world-class brands such as Nestlé and L'Oréal are developing specific products to target this market. My research indicates that a large number of fast-moving consumer goods (FMCG) categories are recognizing the need to take cultural roots more seriously.

The challenge for marketing managers is to understand the psychological need states associated with these complex identity issues and then to develop appropriate brand com-munications to help consumers manage these issues. I conducted extensive one-on-one interviews with eighteen- to twenty-seven-year-old ethnic female consumers—and their mothers—in the suburban areas of Paris. All were born in France (or had arrived before age five). For the majority, both parents were born and brought up outside of France—in Algeria, Morocco, Cameroon, Democratic Republic of Congo, Tahiti, Turkey, the French Caribbean Islands (Martinique, Guadeloupe)—and two of the interviewees had one parent coming from outside of France, Senegal and Sierra Leone.

(continued on page 48)

Reclaiming Cultural Heritage
through the Commercial World *(continued)*

It is within the close bonds of daily life, family stories, and the individual's choices, that the marketers' treasures can be found. These young women were constantly referring to "Here" (France/Europe) and "There" (the village "back home"). Identity issues between their country of birth and their parents' country of origin were particularly interesting, as these young consumers continually switch back and forth between their "inside" culture (family, ethnic group) and "outside" culture (peers, national society). Remembering *there* and engaging *here* can be challenging exercises, because some cultural elements conflict.

In their day-to-day lives, these young women clearly feel they are from *here* and have developed a French identity. Although they have endorsed the consumption patterns of French society, in some situations, they feel they do not totally belong *here*. In their search for belonging, these young women will look for products used by people from *there* (mother, aunts, family back home), that come from *there*, or that are clearly associated with *there* (monoï, henna, kohl, argan oil, rhassoul). When one woman's mother was interviewed about her use of cosmetic products, she explained the Moroccan traditional cosmetic culture. "In Morocco, we have a lot of products for the skin, such as facial masks or makeup products like kohl. You just cannot walk away from these products or henna."

Traditional products from *there* are often not adapted to modern life. The two cultures are in conflict, and the return to the original ethnic culture is selective. Women feel increasingly *not from there*; they have to make choices between what they can implement from *there* and what they reject. This rejection leads them to feel from *here*, and this sense of belonging is traceable to the products and brands they buy and to the points of sale they frequent. For instance, one woman said, "I could not go back to henna, even now. It is so simple to get a hair dye: You go to the hairdresser, he does it, you walk out, and—voila—it's done."

This re-culturation process, or the rediscovery and reinterpretation of an ethnic heritage using brands, products, and ethnic points of sale, is today a key trend among ethnic consumers in France. Instead of assimilating to the new cultural environment, second- and third-generation ethnic consumers are holding on to their cultural heritage and reasserting their difference. In France, cosmetic products from *there* are available in ethnic retail stores, but ethnic consumers also look for practical products from *here*. Although big brands develop products from *here* with ingredients from *there*, consumers want products from both.

TAHITI

In many multicultural markets today, NUDE product and its packaging meets the trend for a simpler, more pure presentation of products and brands. (Design: Pearlfisher)

Products and brands must therefore deal with two issues: from *there* authenticity with from *here* practicality. Ethnic consumers often have identity issues of longing and belonging, and these can be particularly acute.

But they are not alone in this. When we think about our family histories, even the tragic chapters, we all long for a lost or imagined "homeland" and search for roots through our consumption behaviors. Shall we have pasta or Kung Fu chicken tonight?

*Parts of this article are excerpts from a research paper selected by the Consumer Culture Theory (CCT-Boston 2008) and the Association Française du Marketing (AFM-Vincennes 2008), among others, for presentation and publication.

TURKEY

Chapter 5

Twelve Key Determinants to Creating Successful Brands

Determinant 1
History
The Impersonal Determinant

Determinant 2
Logos
It's Often the Little Things that Count

Determinant 3
Brands, Branding
Identity Is Equity

Determinant 4
Longing and Belonging
Unattainable Wants, Irresistible Needs

Determinant 5
Alchemy and Magic
Making Life Worthwhile, Wishing Upon a Star

Determinant 6
Globalization
The Ultimate War Game

Chambers Concise Dictionary (partial definition):

Determine: *to limit; to fix or settle; to define; to resolve; to decide*

Decide: *to determine; to settle; to make up one's mind*

Determinant 7
Curiosity
Looking Under the Rock

Determinant 8
Entrepreneurship
It Is Personal, and It's Not Just Business

Determinant 9
Persuasion
Black Can Be White; Roses Can Be Blue

Determinant 10
Champion Mentality
Winning, Even When You Lose

Determinant 11
Right-Brained Thinking
Come to Think of It

Determinant 12
Creativity
Developing Ideas They Can See and Feel

Determinant 1

History:
The Impersonal Determinant

From *Chambers Concise Dictionary:*

History: *a course of events; a life story; a drama representing historical events*

In the early, dark days of World War II, Russia produced many propaganda posters like this in the early 1940s.

Vladimir Nabokov's early memoir, *Speak Memory*, offers the key to understanding much about his subsequent oeuvre. Writing in Paris as an exile from a life and a Russia that was gone forever, he used his memory and his talent to compose a vivid mental picture of his childhood and environment that was to herald so much of his subsequent brilliant career.

Life and career are always influenced by living memory. Observe and learn, from personal and professional experiences, not only about obvious surface differences but also about the emotional similarities that very different histories and cultures can have in common when one digs below the surface of peoples' memories and stimulates their imaginations.

The best creative brand warriors are able to draw from their personal histories. All great designers have a superior sense of where,

when, and *why* significant events in their past lives occurred. All are able to transport themselves, before they begin to create ideas, to a mental environment that allows their synapses to fire freely. Their search for the appropriate historical backdrop for the genesis of an idea is accomplished almost at warp speed. They have spent years absorbing the drama and comedy of life, as spun out in books, film, and personal travel. Once the gates to their imaginations are open, connections spark one another, and inspiration strikes.

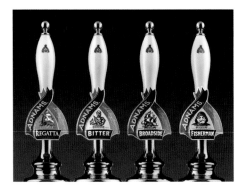

The Adnams beer identity draws on strong historic imagery to demonstrate the brewer's long heritage in Southwold, Suffolk, U.K. (Design: DesignBridge)

1936 to 1945: Hopes and Fears

I was born on December 22, 1935. I don't consciously remember much from earliest childhood, but I do have strong memories of moving into a brand-new house in a new neighborhood when I was five. This part of very early childhood was conventional and happy.

Then, on December 7, 1941, it all changed. I remember to this day what I was doing when I heard the news: I was listening to my favorite radio program, The Gene Autry Show, when an announcer broke in to say that the Japanese had attacked Pearl Harbor. I remember thinking, "Who are the Japanese? Where is Pearl Harbor? What does this mean? Will they be attacking our house?" I soon learned what had happened, about the seriousness of it—and about the war that took place soon after.

I was allowed to listen to President Roosevelt's famous call to action: "This is a day that will live in infamy." A country, which the day before had been ferociously pacifist, was now committed to war in the Pacific. Shortly after the attack on Pearl Harbor, Hitler declared war, and the United States rallied to the challenge of fighting a global war.

Many other things during those war years strengthened my lifelong sense that history is worth remembering and learning from. The overheard stories from neighbors and relatives, fearing the worst about sons and husbands, showed me maps of places I would otherwise have never heard of. I think my curiosity to someday see some of these places was implanted then. I don't think many of my generation ever forgot World War II, even those of us who grew up in the United States and were spared the horrors. I know I have retained a strong feeling that if you want to live free, you must always be prepared to fight hard.

Lou and Fred Cato: the baseball warriors from Arkansas

My paternal grandparents and three of their six children, plus the dog and the mules, in the early 1900s in rural Arkansas.

Able to Leap Tall Buildings in a Single Bound

Most of the heroic stories splashed across the pages of the vibrantly colored comic books of the 1940s and '50s were drawn with an emphasis on guts and glory. The guts were usually spilled by the bad guys, with the glory reserved for the good guys. At a dime a copy, there was a limit to how many we could afford on the meager funds earned cutting grass and washing cars, so we had to beg our parents to shell out for a few extras. We never threw any comics away, no matter how old; instead, we built up our stash and furiously traded them with others. I guess this was a 1940s/50s version of Facebook.

Because of this continuous graphic exposure, I started to draw a lot. I found I could draw far better than most of my friends and became the go-to guy for special drawings. I'm sure this drawing ability was an early clue to the possibility of my using creativity in later life.

Although creative, emotional branding can bridge both language gaps and cultural differences and find emotional common denominators to which diverse audiences are most likely to respond in similar ways, there is one prerequisite for recognizing and understanding the importance of those common denominators: Understand the impact of history on one's own life first. An eclectic knowledge of history's many stories is vital to any would-be creative brand warrior competing for business in this globalized

Mark Kurlansky's book, *1968, The Year That Rocked the World*, is a riveting account of the broad and violent spectrum of events that ignited profound changes in attitudes between generations. Societal persuasion brands came to bloody life in the streets of Prague, Paris, Warsaw, and Mexico City.

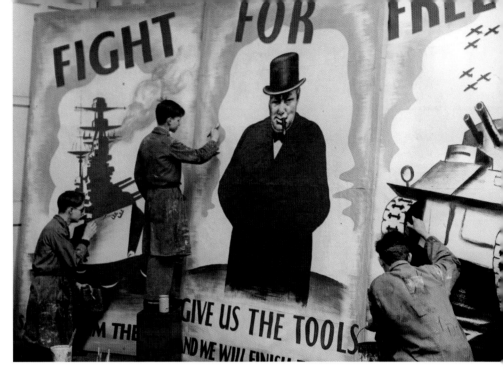

world. Pay attention. Read a few more compelling histories. Watch and learn from both film and documentaries and canvass the global news commentaries, not just the local reportage or YouTube.

For example, in the World War II years, propaganda from all sides was the order of the day; in the West, newspapers, movies, newsreels—most of all, the comics—emphasized the point that brave good guys would triumph in the end.

The story of Berlin has an ongoing fascination for me. At the turn of the nineteenth century, Berlin was renowned for its literature, engineering feats, and scientific advances. Then between 1933 and 1945, the city became infamous as the center of Hitler's Third Reich. In 1945, it was brutally conquered by the Russians, and the city

LEFT: The swastika became the Nazi brand during World War II, forever changing the meaning of that once innocent symbol.

RIGHT: Early World War II poster, featuring Prime Minister Winston Churchill

soon became a global symbol for East/West tensions for almost fifty years. The dramatic fall of the Berlin Wall was a dramatic forerunner for the demise of the old Soviet Union and the beginning of the city's return to its rightful place as an important global center.

I was in the city occasionally in the late seventies and early eighties and was always intrigued by the contrast of West Berlin, glitteringly representing the West's brands of freedom and free markets, and the Eastern sector, which was drab, boring, and more dangerous.

Having survived World War II and the division of
Germany, the Brandenburg Gate stands today as a
potent reminder of the continuity of the reunited
nation.

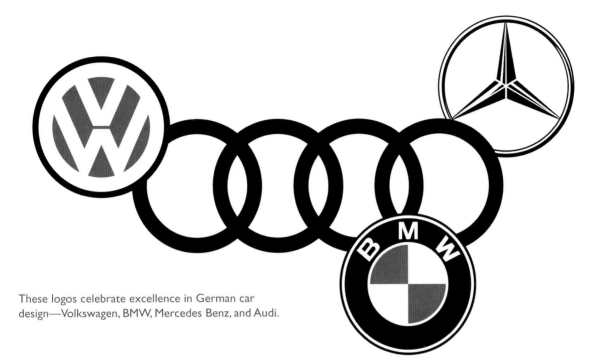

These logos celebrate excellence in German car design—Volkswagen, BMW, Mercedes Benz, and Audi.

Back when Cato Johnson was doing brand work for Ford and Chrysler, we were fascinated with the early history of American automobiles and their founders, Henry Ford and Walter Chrysler. In researching automobiles, we couldn't overlook the design and branding of German cars like Audi, Mercedes-Benz, and particularly Volkswagen, originally designed by Ferdinand Porsche as "the people's car" for Hitler. These automobiles represent excellence in engineering and branding and have a history all their own.

The Ties That Bind

My alma mater, the College of Design, Architecture, Art and Planning at the University of Cincinnati (DAAP) has a long and distinguished history, mainly because of the success of its pioneering co-op system. It has produced many distinguished alumni from around the globe, and I have had the pleasure to be associated with a number of them over the years, including Jerry Kuyper and Michael Graves.

MICHAEL GRAVES, AFIA, *Principal of Michael Graves & Associates and Michael Graves Design Group in Princeton, New Jersey*

Michael Graves's practice has evolved into two firms: Michael Graves & Associates (MGA), providing architecture and interior design services, and Michael Graves Design Group, specializing in product design and graphic design. The firms are based in Princeton, New Jersey, and New York City, New York. The architectural practice has designed over 350 buildings worldwide encompassing many building types: from early projects such as the award-winning Humana Building in Louisville, Kentucky, to more recent work such as the Ministry of Health and Sport in The Hague. MGA has directly influenced the transformation of urban architecture from abstract modernism toward more contextual responses. Architecture critic Paul Goldberger, writing in the *New York Times*, called Graves, "truly the most original voice in American architecture."

The product design practice has designed over 2,000 consumer products for home, office, and personal use, as well as building components such as lighting, hardware, and bath and kitchen products.

My design practice—in both architecture and consumer products—has been an ongoing investigation of a language of forms that express the myths and rituals of our culture. Years ago, I coined the phrase "figurative architecture" to describe my buildings. By extension, "figurative design" characterizes the way my products embrace similar humanistic concerns. I believe that people make natural associations with forms (as well as with materials and colors). Forms that are familiar and accessible can convey meaning because we associate with them. This interest in figurative design counterbalances the modern preference for abstraction, but I don't think the figurative and the abstract are mutually exclusive.

For much of the twentieth century, the prevalent design aesthetic was based on geometry and abstraction. This aesthetic evolved from early modern fascination with technology, with the machine and its metaphors. Computers have created an interest in abstraction. For years, "good design" in both architecture and products was synonymous with "modern,"

Engineering building at the University of Cincinnati

which translated as "abstract." However, I personally find some modern buildings alienating. The identity of their elements—even components as basic as walls, windows, and doors— is not perceptible. Constructs such as window walls subvert the language and strike me as architectural slang. Some modern objects have become so abstract as to be obscure, to the point where you don't know what they are or which end to pick up.

(continued on page 62)

Tea kettle for Target Stores

Clock design for Target Stores

My design goals are to create familiar, figurative forms while also drawing on the lessons of modern composition. I want the design language to be understandable but not simplistic, and what I learned from modernism helps to make this happen. Poet Wallace Stevens once made a comment to the effect that you have to be literal enough to get the reader into the text and abstract enough to keep him there. This is also the way I view a composer such as Mozart. You can enjoy Mozart's music right away, you can hum it, but upon closer investigation you can also discover more and more. In designing everyday objects, I want to encourage the impressions of familiarity and also allow those objects to be seen in a slightly different way. Even useful objects can have a symbolic function as well as a pragmatic one. In achieving these goals, we often combine simple utility, functional innovation, and formal beauty.

(continued on page 64)

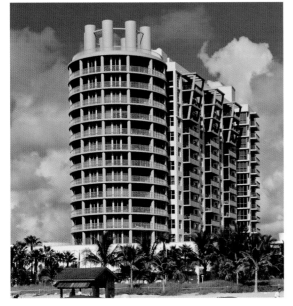

ABOVE: Princeton arts building

LEFT: Oceanside apartment complex in Miami, Florida

The Ties That Bind *(continued)*

JERRY KUYPER, *Principal of Jerry Kuyper Partners in Westport, Connecticut*

Jerry Kuyper has more than twenty-five years of experience directing corporate and brand identity programs. Since establishing his firm, Jerry Kuyper Partners in 2004, he has created identity programs for Boxwood Strategic Advisors, Cartus, Penn Medicine, LodgeNet Interactive Corporation, University of Rochester Medical Center, and the Visiting Nurse Service of New York, Partners in Care. In 2006, Kuyper collaborated with Joe Finocchiaro to develop a new corporate identity for Cisco.

Previously, Kuyper held senior creative positions with leading design and identity consultants, including Lippincott, Siegel+Gale, frog design, Landor, Saul Bass, and Richard Saul Wurman.

My interest in logo design began as a sophomore at the University of Cincinnati. Creating symbolic representations of organizations appeared to be something I might actually be able to explore, master, and do for a living. Forty years later, I'm still passionate about creating corporate identity programs.

Working in this field has done many things.

- It has provided me with an opportunity to work with and develop an understanding of a wide range of businesses. I have had the pleasure of working with the World Wildlife Fund and ExxonMobil, the Center for Attitudinal Healing, and GE—fortunately not all at the same time.

- It has broadened my awareness and understanding of other cultures. I have worked with clients across the globe, from Fuji Bank in Japan to Banco Santander in Spain, from Televisa in Mexico to Valmet Automotive in Finland.

- It has enabled me to collaborate with very smart and creative people on both the consulting and the client side.

I spend a considerable amount of time promoting the importance of visual distinctiveness and expressiveness to prospects and clients. I met my match when a former executive and artistic director at Carnegie Hall told me, "I want to hear beautiful music when I look at our new logo."

(continued on page 66)

TOP: Frontier Renewal is a property acquisitions company.

MIDDLE: As an affiliate of the Visiting Nurse Service of New York, Partners in Care provides quality private home care services to more than 1,000 clients in the New York City area every year.

BOTTOM: LodgeNet Interactive Corporation is the leading provider of media and connectivity solutions designed to meet the unique needs of hospitality, healthcare, and other guest-based businesses.

It became clear that he was not expecting us to bring a boom box to the next meeting, and I realized we needed to set more realistic expectations for what a logo could accomplish.

During our next meeting, I responded, "The new logo will never equal the historic grandeur or have the acoustical magic of Carnegie Hall. However, if you select a logo and use it effectively, it will come to symbolize Carnegie Hall over time."

Unfortunately he was replaced before he selected a logo. But I often ponder his grand expectations for a simple icon and strive to create visual artistry that such a client would applaud.

specialvillage.com

Special Village is a site dedicated to encouraging on-line connection between people with special needs.

Over the years, I have been told by countless brand strategists and marketing experts that, "A brand is more than just the logo." Certainly that is true. However, take a close look the next time there is an announcement from a major company or organization. You won't see the mission or vision statement. You probably won't see their headquarters looming in the background on television. It is unlikely you will see executives surrounded by their products. But in all likelihood, you will see the logo, either as a multiple pattern or as a large unmistak-able symbol of that organization.

TOP: Fusion provides IP-based voice and data solutions to corporations and carriers worldwide.

BOTTOM: Zoom360.net is an online tool that enables viewers to view objects, such as museum artifacts, from multiple angles and to examine the most minute details.

A Perspective

EDWARD NEY, *President and Chairman Emeritus of Young & Rubicam Advertising, New York, NY*

Edward Ney, former chairman, president, and chief executive officer of Young & Rubicam Inc., is credited with the concept of integrated communication specialties (public relations, direct marketing, et al) into Y&R, calling the new offering the "Whole Egg." Former ambassador to Canada from 1989 to 1992, Ney serves on the International Advisory Board of the Center for Strategic & International Studies (CSIS), is a member of the Advertising Hall of Fame, and an honorary chairman of the Ad Council. He is a trustee of the Paley Center for Media and a member of the Council on Foreign Relations.

I became president of Y&R International in 1965 and head of the agency in 1970. I inherited a few problems. In 1971, the worldwide economic recession hit Y&R, our clients, and the advertising business as a whole, really hard. We weren't growing, our payrolls were now too high, and we needed to cut back on expenses.

As chairman and chief executive officer, I made the necessary cutbacks and led a changing of the guard, appointing Alex Kroll as creative director and Alex Brody as head of our international operations. But the turning point happened when a group of the key leaders and I went off to rethink what we were and what we wanted to be. We knew the economy would improve and that our leaner business would grow again, but we also recognized that change was now a constant in the world. Along with our clients, we needed to understand how to prepare to meet new challenges. After days of some pretty intense analysis and introspection, we came to the conclusion that our clients were going to need more from us than just our proven advertising prowess.

So, in June 1972, we finalized our new mission statement: We wanted to be the best in responsible commercial communications on a worldwide basis. Notice the absence of the word "advertising." It seems so axiomatic now, but I do believe we were the first to stake out this new, much broader territory. In a relatively short time, we started to bring this vision to life. Lester Wunderman and his pioneering direct-marketing agency came aboard, as did Matt Hennessey and his leading healthcare agency, Sudler & Hennessey. We merged a number of U.S. regional agencies into a new division and, in 1975, acquired Cato Johnson. The next merger, one that gave me a lot of satisfaction after seven years of pursuit, brought Bill Marstellar and Harold Burson and their outstanding public relations firm, Burson Marstellar, into the fold.

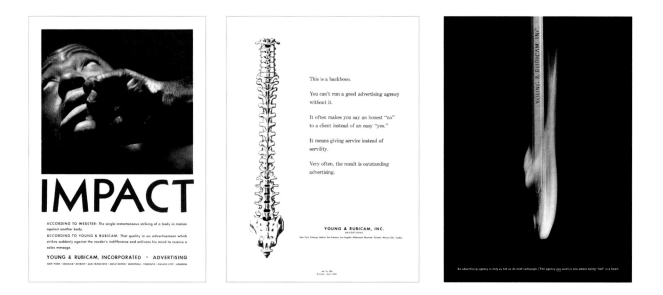

In 1981, again after some years of discussion, we merged our Tokyo office into a joint venture with Dentsu, the very large Japanese agency. The new subsidiary, called DYR, was intended to give Dentsu a firmer foothold outside of Japan and strengthen our position in Japan. The next few years were good ones for us across the board, but in 1985, it was time for me to step down. Alex Kroll became CEO, and the agency continued its success through the eighties. In the late 1990s, Y&R successfully went public, and today it's an independent arm of WPP.

My perspective today, through all the changes I've witnessed and experienced, is essentially the same. We must help clients build meaningful connections in the lives of their customers. We still believe in creating ideas that act as catalysts for building businesses, big ideas that travel well and create real, measurable change for client partners.

These three house ads from different decades demonstrate that, although styles change, Y&R's commitment to creativity does not.

TRADE MARK

The **LONE RANGER**
COLLECTION

ESTB 33

· ESTB · 1995 ·

anjou
BAKERY

A&M
UPHOLSTERY

TRADE MARK

SPIRIT
AEROSYSTEMS

SeaWorld
BlueTeam

Determinant 2

Logos:

It's Often the Little Things That Count

From *Chambers Concise Dictionary:*

Logo: *A small design used as the symbol of an organization*

A sampling of logos for different industries.

Top row: Lone Ranger Collection; Anjou Bakery
Middle row: A&M Upholstery; Spirit AeroSystems
Bottom row: SeaWorld Blue Team; Martens Appraisal

(Design: Gardner Design)

his four-letter word, with "go" and an exclamation mark added, represents the crux of the brand's importance and is intended to evoke an emotional opinion. Are you positive or negative about the implied message? Logos are generally meant to be positive marks of recognition. Obviously, some logos send out negative messages to some audiences, but, even then, it is likely that the logo's original developers were addressing a specific audience with a specific positive message.

The title of this book is meant to be unambiguous; it is an imperative command, a challenge to all brand doubters. Every logo starts its life with an ambitious, positive mission. All parties who commission the design of a logo, even those who opt to buy six examples for $25, as advertised on Google (look it up), envision their brand, business, institution, or cause ablaze in full color and megawatt lighting, selling their presence and "availability." The ancient Greek meaning for *logo* (spelled *logoi*) described significant religious and philosophical convictions, and some logos today still have this intention. But the majority of logos, even those designed by highly trained designers, are destined to a life of relative obscurity. It takes the full power of a disciplined organization, a lot of time, and usually a lot of money to gain the exposure required to transform "a small design" into a globally meaningful identity.

Giep Franzen and Margot Bouwman, in the introduction to their book, *The Mental World of Brands: Mind, Memory and Brand Success*, list four elements they consider to be necessary to any definition of a brand. I've paraphrased these to relate specifically to logos:

A brand *essence* exists only in the memory of people. The *logo* is the highly visible reminder.

A brand *logo* is a multi-use sign of recognition (labels, signs, events, ads, packaging, the world wide web, etc.).

A brand *logo* evokes associations in people.

A brand *logo* can be linked to both commercial goods or services and societal persuasion causes.

The following distinctive logos instantly identify the brands they are representing.

Design: Bright Strategic Design & Branding

Design: C&G Partners

Design: Gardner Design

Design: Gardner Design

Design: Doyle Partners

Design: Doyle Partners

The initial work in designing a new logo for a major brand is the most personal, and perhaps the most creatively rewarding, assignment an individual brand warrior will tackle. The state of mind that designers enter into when they begin the process of developing a new logo is, in a special way, a creative state of grace. Following what is usually a collective briefing session from the marketing team, all the designers—and there will be several—go off to work in isolation. Their workstations might be adjacent to others, but, for each designer, the process at this stage is private.

Each designer now tunes into the stereo channels of his creative subconscious and the cognitive facts, now playing in his mind. After a bit of fiddling with the controls, the creative melodies start to flow. Switching back and forth from rational thinking about specific objectives to the world of their subconscious feelings, the "what if" ideas begin to take shape and are transferred onto paper or a screen.

Once each of these tenuous creative thoughts become visible, however, the rational judgment process begins to intrude:

Logo for Alhurra TV, a U.S. television network broadcasting throughout the Middle East (Design: C&G Partners)

"Do my newly born creations match up to the hopes I had when my concepts were safe in the womb of my imagination?" In my experience, the first manifestations usually don't, so the process of evolution begins. "What happens if I try it this way? Or if I tried it like this?" One variation leads to another, until the designer feels enough is enough. "Now I'm ready to expose my thinking and my solutions to the scrutiny of others." This is, of course, when the creative ego is in its most vulnerable, and least objective, state.

I've been in this position over and over in my career, though not as a creative designer for a long while. But as a designated project leader, I have stood before steely-eyed juries thousands of times. And the moment just before the actual presentation of the creative case is critical. The mood in the jury box is one of expectation, and it's not always benign. There almost always seems to be a collective sense of apprehension among the jurors (before any work is actually shown) that "these designer types might try and pull the creative wool over our eyes. We must be very objective in listening to the presentation of the work we are about to see."

Notice I said "listening." While the work to be reviewed is visual, the immediate response from the jurors will instantly come from their collective subconscious, and it

U.S. Green Building Council is a nonprofit organization that leads efforts for sustainable building practices. This logo exemplifies Giep Franzen's and Margot Bouwman's definition of a logo. (Design: Doyle Partners)

will be verbal, even though the opinion will, for the moment, be unspoken. They will be thinking: "I like it. I don't get it. I hate it. This is really interesting. Let's see the next one." This is why every experienced presenter, knowing how hard it is to counter (or encourage) an instant prejudice, must be as imaginative in selling the concept as in creating the work itself.

The odds are strong that, initially, the jury is likely to be in a mood of left-brained skepticism. So, going with the analogy of the presenter as a good trial lawyer, the

Creating a Visual Vocabulary

Cato Associates was charged with developing a new identity system for Healthnotes, a company that creates and distributes scientifically based information on complementary and alternative medicine to retailers, healthcare professionals, and consumers. Art director and designer Katie Warner created the vibrant identity system that brings together images and icons from all cultures, visually bridging the worlds of conventional and alternative treatments in healthcare.

opening argument must free up the imaginations of the jurors, choosing words to paint a mental picture. The best ones create a story that opens the emotional doors to the subconscious of the listening—and now viewing—jurors.

The primary objective here is to *verbally* illustrate the visual work being presented by combining emotion and logic to convince the client of the merits of the ideas presented. Even an outstanding piece of work, one that powerfully brings the magic of the idea to life, may not survive unless the presenter can persuade the client audience that these ideas are going to help their products fly off the proverbial shelves. Go logo!

If I am in the role of project team leader, I am always conscious of the need to emphasize to the creatives that the first submissions are initial work only and that each will be treated as tenderly as innocent newborns. Out of the discussions that follow the individual designers' presentations and a review of the original analysis and research, the

most likely contenders are chosen for further development. This is when the true creative brand warriors join ranks, becoming a team again. Usually the journey to an accepted logo and the development of a supporting communication program is a long and arduous one and requires close involvement and cooperation from each creative throughout the process.

If the overall objectives are achieved for the brand, and the introduction of the new logo is judged a success, all the team members can feel justifiable pride. But the individual designer who initially created the "winning" concept will always believe, "That's *my* child that grew up to be a famous personality."

Sometimes, the power of a logo alone becomes symbolic shorthand for a greater, more overarching idea. Today's brand warriors need to fully explore and understand the underlying emotional strengths of a global brand's logo. It often serves as the tip of the brand iceberg, signaling that there is a lot more beneath the surface.

Think Before You Leap

SIRKKA RICHERT, *principal of Designsyndicate, London and Brunei*

Sirkka Richert is the creative director and founder of Designsyndicate, a multidisciplinary communications company in Brunei. Richert has worked as a designer since 1992, exploring the wide-ranging facets of graphic design and, in recent years, specializing in brand development. The Designsyndicate team is a global collective of trend spotters, writers, market analysts, and graphic, product, and web designers.

To strive for the best ideas and turn them into sustainable design solutions, several things need to be considered.

- Looking in from the outside: We cannot afford to look at a problem in an isolated manner. We need to understand the opportunity by dissecting all its components—the history of the company, where it is positioned at present, where it wants to go in the future, and how it rates among its competitors.

- The time we live in: Detect, analyze, and evaluate trends. Where does our logo design stand within the context of sociological, economic, cultural, and even technological changes? How will it survive the changing times?

- Artistic ego and customer expectations: Harnessing one's own artistic ego by both meeting the objectives of the brief and delivering surprise and delight.

- Clarity of message: The right image is worth a thousand words; say more with less; form follows function.

How can we look a client straight in the eye and present a design solution with confidence, unless we fully understand their company set-up, their products, what makes them stand out from the rest, and what their customers think? Solutions need to be based on thorough research for a design solution to deliver a convincing message. A designer's curiosity should know no boundaries. It should extend past the immediate problem and draw from a fund of all-pertinent information; only by doing this can we gain new vantage points and a wider, deeper, different perspective to the problem.

(continued on page 80)

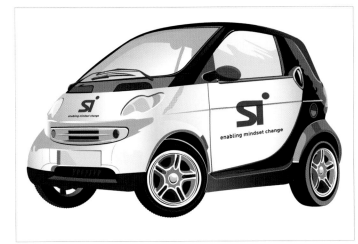

TOP: Children for Children charity logo

MIDDLE: Speakers International logo

BOTTOM: Silverstone Gold Racing tickets

Think Before You Leap *(continued)*

We are surrounded by brand icons. They are in the streets, on TV, in the cinema, and on websites and mobile phone displays. We see them as sponsors at sports and music events and even as cloud-like messages in the sky. We are bombarded by iconic imagery every day; some estimates suggest that we see as many as 6,000 logos per day, all telling us their different stories, trying to communicate an enticing brand message. It isn't enough to put a logo on a letterhead and hope it wins some recognition. The enormity of today's visual pollution means that logos have to work a lot harder to stand out. A well-conceived brand construct or personality is required to succeed, or even just survive, in today's commercial and societal environments. An interesting, compelling story, one that the audience can identify with and believe in, is an absolute mandate. Once a brand personality is established, its key messages require maximum exposure through all media channels. Diligence is needed to stay in tune with its target audience; the brand message must move with the times if it is to stay positively connected with its customer base.

The success of a logo cannot be judged by its artistic execution alone. It is absolutely essential that we turn a critical eye on our creation and be realistic in our assessment. Do we really think it can survive and even flourish in the real world? If it is intended to compete in the global marketplace, how well will it work in diverse local markets? Is it flexible enough to be effective across all media?

Can the design convey an essential message visually, with or without the help of text? From logos to advertising, from road signs to annual reports, from underground maps to product manuals, our goal must be to communicate meaningful messages. There are many, many times when the logo alone must communicate powerfully on an abstract level, delivering a strong, subconscious message to a multicultural audience. Logos achieve long-term success by saying more with less.

With information channels around us 24/7, a designer should thrive on knowing and understanding what's happening the world over. How can we cut through the clutter if we don't understand the clutter? But once the course is set, our mission is clear: Turn information into knowledge, use creative magic to turn the humdrum into stimulating, visual messages that cut right through that clutter.

Graphic design is an evolving and ongoing search to communicate as much as possible with as little as possible.

TOP: Blue Creative Communications logo

MIDDLE: California Health & Longevity Institute promotion

BOTTOM: Kasaka River Lodge in Zambia promotional brochure

FIFTY FOURTH

2000 WORLD SERIES

LITTLE LEAGUE
AUGUST 26TH IN WILLIAMSPORT, PENNSYLVANIA

HONDA RACING

THE DRIVING FORCE

HONDA
IN AMERICA

HONDA RACING

dreamlab

Determinant 3

Brands, Branding:
Identity Is Equity

From *Chambers Concise Dictionary:*

Brand: *a piece of wood burning or partly burned; an instrument for branding; a mark burned into anything with a hot iron. Also defined as: a trademark; a particular class of goods.*

"Brand territory" is a term used extensively by marketers and agencies, as a sort of shorthand to signify a brand owner's cognitive ambition to occupy, or own, a specific commercial space in the minds of customers and consumers. The brand warrior's job isn't done until a "total brand domain strategy" has been nailed down. The goal is to provide clients with the most holistic definition possible for the emotional space their brand would like to occupy.

For the purpose of this book, "owning" a brand domain means achieving extensive and dominant physical and mental presence in as many retail selling spaces as the client's budget allows. The broad definition of "presence" includes examining all feasible opportunities to develop original programming (content) for as many media formats as possible. The ultimate brand goal is to achieve dominance in its key product categories and markets—and achieve iconic "brand meaning" stature in the minds of all target audiences.

To achieve this is an almost-Herculean task, and it's an impossible one without an imaginative, innovative, and flexible strategy. The ongoing challenge of building and maintaining category leadership for any brand can more readily be achieved when the

These two powerful P&G brands work well across borders. (Design: LPK)

The Joseph Banks brand is eloquently carried through on its packaging using a different color for different chip varieties. And not to confuse distributors, the look is successfully carried through on large crates of the product. (Design: DesignBridge)

company's marketing and creative resources are fully aligned with top management's vision for overall operations. The vital core of the brand's domain includes, of course, the less-familiar parts of the organization that are responsible for production and sales globally and locally. In fact, the company's corporate brand can be better known to stockholders, the global financial community, government regulators, competitors, and retailers than to consumers. For example, for many years, Procter & Gamble kept a low corporate profile by letting its leading global consumer brands, such as Tide, Crest, Pampers, and Pantene, take the limelight.

Global commercial persuasion brands offering life's modest little pleasures, such as a Coke or a Pepsi, can remain immodestly

successful, but only if they recognize the change in consumer tastes and are able to master the use of new media. In this connected world stage, the players can now literally and virtually create their scripts and choose how and when to act.

Consumers have quite definitely become more fickle. The twenty- to twenty-nine year-olds continue to claim ambivalence to well-known brands, but the evidence doesn't always support this contention. At the other end of the age spectrum, the sixty-to-seventy-plus audience, while primarily loyal to many old favorites—especially those brands that have learned not to condescend to their chronological age—are embracing brands that are easier or more pleasurable to use.

The following six brand assets (in addition to consistent profitable growth) should rank above all others.

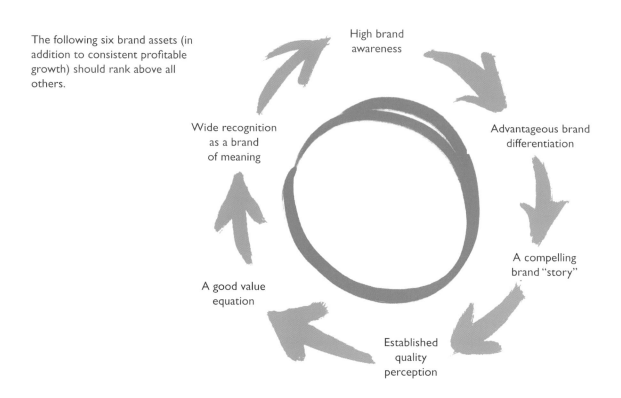

High brand awareness

Advantageous brand differentiation

A compelling brand "story"

Established quality perception

A good value equation

Wide recognition as a brand of meaning

There are many books on branding—too many to count. But here, briefly, are the essential questions that brand warriors must ask, and answer, about an existing brand before tampering with its emotional core equities.

- What is the brand's perceived image now?

- What was it before?

- What could it become?

- What does the brand need to do to get there?

Consumers recognize the name and "look" of the brand. This is the first—and last—stop in a self-fulfilling cycle, which is often referred to as a "virtuous" brand circle.

Consumers understand and remember a brand's stated point of difference. A good example is L'Oréal's "Because I'm worth it" campaign.

The brand's stories match consumers' subconscious wishes, such as Nike's "Just Do It."

BMW's "The ultimate driving machine" campaign is remembered, even after the

Delta Moves On

△ DELTA

Delta Air Lines recognized that both business and holiday travelers have a wide spectrum of choices for their air travel needs. The brand's marketing communication and sales teams, understanding that competing via fare packages alone is not enough in the competitive United States and global markets that the airline serves, called in Lippincott.

The Lippincott and Delta strategic/creative teams developed a total repositioning, an image revitalization, and a customer experience redesign. The new marketing program features both the updated corporate/brand logo and a dynamic new image campaign that features colorful, sophisticated images and communicates Delta's intrinsic value message of customer well-being across as many customer contact points as possible, including its website.

Design: Lippincott; Photography: Albert Vecerka/Esto

Oxford University logo

Graduates of prestigious universities, including Oxford and Cambridge in the United Kingdom, and Harvard in the United States, have brand associations of excellence and positive personal identity credentials wherever they go. Often, even nongraduates don apparel with these university emblems because of the positive association.

Cambridge University logo

Harvard University logo

campaign ends. Its reputation for consistent, high-quality product overcomes price comparison. Consumers often credit strong brands with values beyond simple "product" performance.

Great brands establish rich histories by assiduously accumulating lots of "little stories." These can be created by both the organization itself and marketers. The evaluations and judgments by critics are harder to manage but always worth trying for. And, because most manufacturers aren't primarily in retail themselves, the opinion of retail sales personnel is fertile ground for "persuasion." The strategic and creative use of the

Internet has also become critical. The most agile marketers are creating and sponsoring "content" that can be precisely aimed at target audiences' personal interests.

Some famous brands undergo a major metamorphosis, moving completely away from their former meaning and logo. 3M, for example, was originally Minnesota Mining and Manufacturing Co. IBM used to be International Business Machines. And then there's the Nobel brand. Having started as the name of a Swedish manufacturer of destructive materials and explosives, the Nobel we know today, the Nobel Prize, is a very different brand.

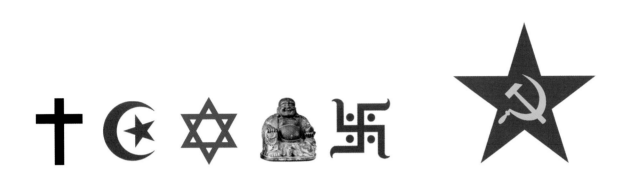

Societal Persuasion

Now what about the other, much larger organizations that manage societal persuasion programs for powerful brands of meaning? Do any of the same rules apply? At a stretch, the answer is *yes*. Any list of the world's major societal persuasion brands is virtually a history of the modern world in itself. The psychological need to believe in something enduring is based on hardwired, spiritual needs. Throughout history, when societal persuasion brands achieve a high degree of recognition, through constant exposure and close association with a defining idea, the brands themselves become simple but powerful symbols of what can be very complex brands of meaning.

In 1918, the Soviet Union's hammer and sickle icon started out by representing idealism, the pure communism of Marx and Lenin. But by 1988, with fifty million Soviet citizens

dead, this symbol was more feared than loved. How about the Christian Cross, the Muslim Crescent, or the Jewish six-pointed star? There is an immediate emotional understanding of the different organizations represented by these brand identities. The world has changed, but human nature hasn't.

Now, surrounded by commercial persuasion brands of an almost infinite variety, we have the liberating freedom to choose those brands that satisfy some personal sense of identity. You might say, "I need a new pair of jeans, but I want them my way." This is what makes life so complicated for marketers (and their global brand warriors). The consumer is definitely in charge. The life of a brand cannot remain static, even in societal persuasion causes. It must change to match the changes its audiences want to make in their lives and their styles.

Consumer Product Marketing 101

JAMES TAPPAN, *Former President of Procter & Gamble in Mexico and United Kingdom and Former President European Operations of General Foods*

James Tappan has had a varied career as a top marketing professional for consumer goods. He worked for sixteen years with Procter & Gamble, from 1960 to 1976. Then, in 1976, he joined General Foods as the president of European Operations in Brussels, Belgium. The European product categories included coffee, desserts, candy, chewing gum, beverages, and meat products. On his return to General Foods's corporate headquarters in 1981 as a group vice president, his assignments included several different consumer products, such as pet foods, cereal, and baking products. In 1988, Tappan moved into the private equity side of consumer products for various companies, selling hair accessories, beer, wine, spirits, baby foods, books, frozen desserts, sunglasses, and carpets.

My experience suggests that two criteria must be met if a product is to be successful. First, it's critical to determine what the consumer wants in a product and how to provide it on a consistent basis. Second, it is imperative to tell the consumer how the product provides the desired benefit in a relevant and easily understood manner.

My first product assignment at Procter & Gamble was Crest toothpaste. Research indicated that consumers, especially moms, wanted a toothpaste that would prevent, or at least reduce, the number of cavities that most children experienced.

The challenge became how to communicate to the consumer that Crest actually helped reduce tooth decay. Advertising campaigns were developed, including an iconic "Look Ma, no cavities" approach, but the consumer did not believe that Crest reduced tooth decay. After years of clinical testing, the American Dental Association finally recognized Crest as being effective in reducing tooth decay, when used in conjunction with a program of good dental hygiene.

With the ADA's seal of approval, moms began to believe that Crest worked, and the results were phenomenal. Within six months, Crest's market share increased 50 percent, and it became the market leader.

Ariel Detergent, Mexico

Focused research and humorous creativity built a laundry detergent into one of the leading brands in the country, if not the world. Procter & Gamble introduced Ariel Detergent to Mexico in the mid-1960s. The first enzyme-based detergent offering superior cleaning performance, Ariel had already been successfully introduced in Europe. P&G used a similar package design and a television campaign explaining the innovative cleaning aspects of the product in the Mexican market. It didn't work.

Ariel has come a long way from those early days in Mexico. It's now a leading wash-day brand in many parts of the world.

Research found that Mexicans consumers did not understand the enzyme story. Nor did they care. The introductory advertising campaign failed to capture the interest of the consumer and failed to generate sufficient trial.

Research revealed the following results.

- Confirmation that Ariel delivered the cleanest laundry results in Mexico.

- Although only 1 to 2 percent of homes in the country had washing machines (the majority of consumers used buckets or did their laundry in the river), the automatic washing machine was the gold standard in the laundry world.

- Mexican consumers preferred humorous advertising over serious, scientific-based advertising.

Armed with this information, P&G and its advertising agency developed a campaign featuring a funny-looking salesman carrying a number of buckets on his shoulders, who walks into the main square of his local town and shouts, "Automatic washing machine for sale." The ladies in the square gather around him to question his sanity, because all they see are his buckets. The salesman takes a bucket, fills it with water, Ariel, and dirty clothes. Within seconds, the bucket starts to agitate, the Ariel generates lots of suds, and the clothes come out amazingly clean. At that point, the salesman proudly proclaims "Ariel turns your bucket into an automatic washing machine."

(continued on page 92)

The Mexican consumers got it. Based on this concept (and product superiority), Ariel became Mexico's leading laundry detergent within two years.

The lessons from this story are simple:

- Do your homework. Testing and research are keys in this process.

- Do not assume that a successful advertising campaign is transferable from one country to another.

- Don't be reluctant to recognize mistakes and implement corrective activity.

Maxwell House Coffee, France

From 1950 to 1980, Maxwell House was one of the leading coffee brands in the United States. The advertising claim, "Good to the last drop," was accepted and even embraced by multitudes of U.S. coffee drinkers. Believing that Maxwell House would be readily accepted in countries outside the United States, General Foods conducted extensive research in France to determine its potential. Research indicated that French coffee drinkers liked their coffee much stronger, so General Foods developed a Maxwell House coffee with a deeply roasted flavor specifically for this market. However, although consumers liked the product, they did not understand the advertising campaigns used to describe the product taste.

Then, during a session with the advertising agency, a U.S. creative director, who was drinking the coffee, said, "Maxwell House is so strong that a spoon can stand up in the cup."

The creatives looked at one another, and all agreed they had just heard the "big idea." Print and television campaigns featuring a spoon standing upright in a cup of Maxwell House were developed. The French consumer grasped the concept, and Maxwell House sales increased significantly within twelve months.

These stories demonstrate that, although the products were designed to be responsive to consumer desires, the initial advertising and marketing campaigns didn't clearly communicate the product benefits in a relevant and understandable manner. However, once advertising was developed that did communicate product benefit in a relevant manner, the brands enjoyed substantial success.

Hidden Magic Hairspray, United States

During the 1960s, the women's hairspray market was large and growing. Research clearly indicated that women wanted a hairspray that kept hair in place without leaving it stiff. So Procter & Gamble developed a product that achieved control, while leaving the hair soft and flexible. Research indicated that the brand name "Hidden Magic" was favorably received and easily understood by the consumer.

The advertising featured a spokeswoman called Wanda the Witch, who demonstrated the product benefits of Hidden Magic with flexinol. The brand achieved great success in test markets and was nationally expanded within a few months. Hidden Magic's national introduction appeared to be a success, and clearly P&G had created another winner.

Unfortunately, within a few months, the company started to receive complaints from beauticians and consumers about Hidden Magic's performance. Yes, the product provided the hair control women desired, and, yes, their hair remained soft and flexible. However, women were complaining about two most unfortunate end results: Women who bleached their hair with peroxide found that Hidden Magic imparted a green tinge to their hair; and others complained that, while outside, their hair attracted bees.

Further product research indicated that the sunscreen in flexinol was the culprit. Hidden Magic was quickly reformulated, but the damage was done, and it was withdrawn from the market in a few years at a loss of several million dollars.

This advertisement for Hidden Magic Hairspray appeared in the 1965 issue of *McCall's* magazine.

Brand Identity: Creativity with a Purpose

LORI KAPNER, *Principal of Kapner Consulting in Scarsdale, New York*

Lori Kapner began her career in journalism, where she honed a commitment to accuracy in language and message. Eventually, she moved into marketing and sales for graphic design firms in the mid-1980s, where she could inject more personality and creativity into her writing on a daily basis. This is when she began to recognize the critical connection between words and design in communications, and between emotional and intellectual perceptions. She is now a corporate identity consultant.

A number of years ago, I was on a plane to Europe. I began to talk with the woman next to me, and we talked about our professions. Because there's no business harder to describe than corporate identity consulting, I began my explanation by asking her what company or product she is most loyal to. Before I even finished the question, she smiled and said—with real conviction—"AT&T." I asked why she was so sure.

Her story was unforgettable. When she was a girl in Europe in the 1940s, her family was persecuted. They had to leave their home, but before doing so, her father showed her where he had sewn valuables into the lining of a coat, just in case. This woman did ultimately lose her entire family but somehow retained possession of that coat.

While she was making her way alone to the United States, she opened up the coat lining. There, she found money, which was now worthless, and AT&T stock certificates. It was the proceeds from the certificates that allowed this woman to start a new life, and her gratitude to this previously foreign company had never faded. She swore she'd never switch to an AT&T competitor—ever.

Clearly, this is a case of brand loyalty in the extreme. That woman would forgive AT&T for a multitude of sins because they had proven benefit to her, immensely personal benefit. The emotional component of branding surely existed in this example. But to compete in today's increasingly cluttered media world, the connection needs to be on both emotional and intellectual levels.

Traditionally, the corporate identity "industry" involved name and logo development for new or merging companies. Over time, though, complexities in the marketplace, globalization, and increased competition put pressure on corporations to stand for, and communicate, a sustainable point of difference from their competitors.

Getting to the Core Message

Our goal as corporate identity developers was not merely to help companies create a more exciting name or logo or store design but to help them position themselves better against existing and anticipated competitors—precisely the issue of concern in a complex business environment.

Corporate CEOs were receptive to what I call "brand therapy": studying all the messages they convey to uncover the true essence of their brand, the core aspect of their business on which all communications should be based. Perhaps this is where my journalism training came in handy; getting to the core message is akin to searching for the truth amid a clutter of information. And, although the output of each assignment varies, our disciplined process does not. The beauty of a rational, step-by-step approach to creative development is that it yields unanticipated yet spot-on results.

Perhaps specific positioning or messaging was not necessary decades ago, when ten brands of chewing gum were displayed on the store shelf, rather than the 1,000-plus varieties now sold in the United States alone, or when two banks competed in a given locale, as opposed to today's numerous general and specialized financial institutions vying for business. Compounding the challenge of brand proliferation is the expansion of purchasing channels from physical branches and stores to telephone and online "locations."

Disciplining the Creative Process

Once the very essence of a brand is captured and articulated, every identity element (vocabulary, organization and product nomenclature, the look and feel of all communications) must support and reflect it, varying the message as appropriate for each audience—within boundaries.

(continued on page 96)

1889

1900

1921

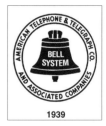

1939

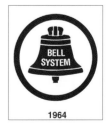

1964

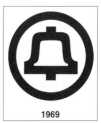

1969

These graphic executions represent the evolution of the Ma Bell and AT&T logo over time

This is where discipline in creativity becomes paramount. Management of a brand over the long term requires a thoughtfully developed and implemented strategy that provides direction for resolving such issues as how and when the brand name and logo should be used, precisely how to apply the identity to a range of media, and what process to employ in creating sub-identities when they are deemed appropriate. In short, a brand provides a framework within which future growth, alliances, mergers, and new products and services can be accommodated.

Last but not least, all can be lost if a new identity is announced to the world without explanation. A targeted positioning, a brilliant name, an expressive logo, perfectly synchronized implementation—all this effort can only be appreciated by a brand's constituents if they understand it! Certainly a name is more memorable if it means something to people, and a considerable opportunity is missed if the name appears to be meaningless. Some companies understood this concept from the start. Apple celebrated the launch of its name in the 1970s: an unconventional name to represent an unconventional offering. Google, another name in need of an explanation, offered theirs when it was launched: It is derived from "googol," a word meaning "one" followed by 100 zeros. The name is relevant and symbolic of the company's mission.

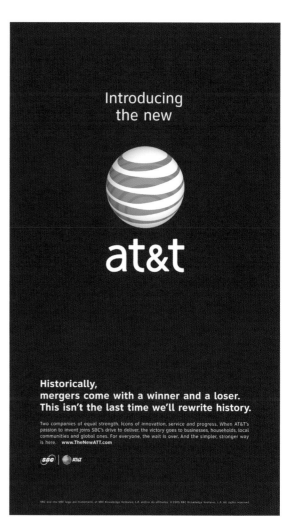

In contrast, the introductions in recent years of Verizon Communications (formed by the merger of Bell Atlantic and GTE), and the ill-fated Monday (formerly PwC Consulting) failed to explain the connection between the big news of the company change and their deliberately chosen monikers. Although Verizon is an extremely successful company now, the initial response from consumers was confusion. Created and managed properly, branding will do what it's intended to do: serve as an important means for illuminating and communicating what's unique about a company.

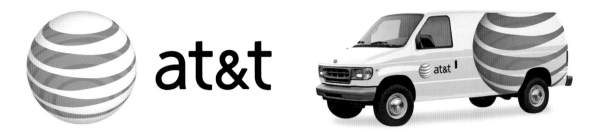

Design: Interbrand

As for AT&T, it is hard to imagine another brand that has weathered as many business twists and turns: the breakup of the AT&T monopoly in 1993; the effects of industry de-regulation in the United States; expansion of service from long-distance phone to today's broad complement of communications services; acquisitions of regional and cellular service providers—all in all, an exhaustive series of changes!

On more than one occasion, management considered abandoning the AT&T brand but decided each time that awareness is more than half the challenge. Despite ups and downs in its business and its reputation, the AT&T name was more valuable as a cornerstone on which to build a desirable image than any of the acquired identities or the prospect of a new and therefore unknown moniker. In essence, the new mark (which meant making changes to more than 24,000 company buildings, 83,000 automobiles, 6,000 retail stores, 55,000 hard-hats, and more) initiated an image shift that emphasized approachability and flexibility.

Clarity and Consistency are Key

Companies such as AT&T know that creating and sustaining a global brand requires consid-erable investment, that customers buy the brand as much as the product, and that the most desirable employees are attracted to companies that own respected brands. At the heart of our technological world beat the hearts of consumers and business buyers, who will always choose what they best understand and recognize.

Ultimately, where service and other product or corporate attributes are equal, a brand mat-ters very much. There is no way to buy brand loyalty; in fact, it is garnered by means other than money or price. Surely the woman I met on the airplane years ago will attest to that.

Determinant 4

Longing and Belonging:
Unattainable Wants, Irresistible Needs

4

From *Chambers Concise Dictionary:*

Longing: *an eager desire, craving, yearning*

Belong/Belonging: *to pertain to; to be the property of; to have a proper place in; to be entirely suitable; to be a member of; conforming to social norms*

These high-end cosmetics are coveted by female consumers, who are very much influenced by the stylish brand designs. (Design: Ken Hirst)

L onging and belonging. These two words succinctly represent the causal, emotional strengths of most great global brands, an eager yearning to be included. Of course, the deep thinkers, in their philosophical literature on consciousness, argue about "free will": Do we have it or not? Douglas Hofstadter, Ph.D., the author of *I Am a Strange Loop*, has no problem with this version of free will. He says, "I did it because I wanted to, not because someone else forced me to." However, he emphatically points out that, sometimes, "Our desires bang up against obstacles," adding, "Our will alone does not get us what we want. It pushes us in a certain direction, but we are maneuvering inside a hedge maze whose available paths were directed by the rest of the world, not by our wants . . . A combination of pressures, some internal and some external, collectively dictates our pathway in this crazy hedge maze called life."

From our earliest histories, people needed to feel secure with themselves and with where they fit in their local societies. Local groups gradually developed their own stories and powerful cultural myths to help them understand how they fit into a larger world. The more successful brands, both commercial and societal, are anchored in myths. Our imaginations differentiate us from everything else in our natural world. Our need to believe in something enduring has sparked the creation of most of the "isms" in mankind's history. Religions of every kind, political systems, and tribal loyalties all consciously use the power of defining myths and their corresponding emotional languages to trademark their particular domain. Cathedrals, temples, and castles; signs and symbols; uniforms and slogans—these kinds of historical benchmarks all have a common raison d'être. All have been used to appease our emotional longings and appeal to our hardwired need for belonging.

Have you ever really thought about *why* the world's major religions and our oldest forms of organized governance have survived and thrived for millennia? The surviving winners in both of these high-stakes games are here to stay for one compelling reason: We need them. Philosophies and religions, two of history's most powerful belief systems, have always been based on reasoned conjecture about abstract concepts. In the same, very general sense, much of our art, music, and literature is meant to capture elusive feelings about truth and beauty—and a yearning for a spiritual authority.

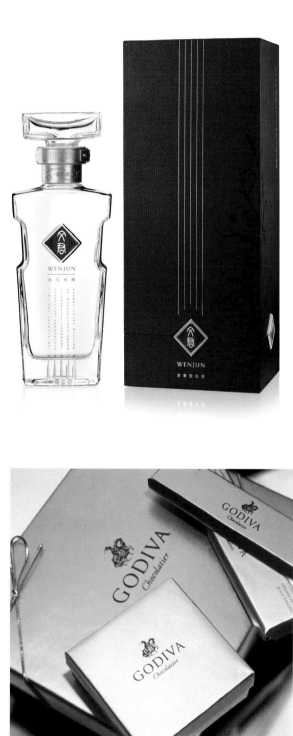

These high-end brands communicate luxury and the good things in life. Beefeater 24 and Wenjun whiskey logos and package designed by DesignBridge; Godiva chocolates logo, designed by Michael Bierut, Pentagram.

In a more contemporary context, this psychological need to belong takes many forms, conscious and subconscious. For example, a middle-aged man in Wiltshire, in the United Kingdom, is quite conscious of his desire to be generally identified as belonging in a specific demographic, sociographic typecasting. His belief is: "I'm a conservative, middle-class, rugby- and cricket-loving, Tory-voting, pub-going family man and proud to be British."

A younger woman living in New York City, for example, will literally want to be seen (and heard) to be a member in good standing of a recognizable social group. Her belief is: "I'm a young, party-loving fashionista who just wants to have fun with my friends and forget all about my boring, dead-end job." Neither person is particularly keen to be singled out only by their leisure habits, nor do they want to be identified solely by any religious or political beliefs. But each is

"I'm a conservative, middle-class, rugby- and cricket-loving, Tory-voting, pub-going family man and proud to be British."

certain to forge strong loyalties to the kind of brands they consciously, and subconsciously, choose.

In *No Logo*, Klein laments that many things people buy are *not* to meet "needs." This is certainly true, and that is precisely the point. As so many psychologists, psychiatrists, anthropologists (and now neurologists) consistently posit, we crave more than shelter, sustenance, sex, safety, and spiritual solace. Some of these scientists even speculate that shopping itself is a deeply rooted need, and the evidence of markets and bazaars as social meeting places throughout history would seem to justify this. As stated throughout this book, people everywhere pursue satisfaction in life by seeking to meet their wants. The opportunities to scratch those shopping itches are endless, and the competition between sellers is intense, which means more opportunities for the world's best creative brand warriors.

"I'm a young, party-loving fashionista who just wants to have fun with my friends and forget all about my boring, dead-end job."

A Need To Belong

KATIE WARNER, *Principal of Studio Three Creative in London, England*

Katie Warner studied design at Central/St. Martins School of Art in London and took her postgraduate studies at the Warsaw Academy of Art in Poland. In her career, she has worked for London's leading design consultancies and held senior positions in creative agencies in both Paris and Singapore. She set up Studio Three Creative in 2000 and continues to work with Mac Cato on both U.K. and global projects. Most important, she is known to both her clients and her peers for having an exceptional balance of creative talent and intellectual prowess.

We live in a time when the family unit is disintegrating; many of us are away from home in foreign environments and live transient lifestyles. With the advent of Facebook, MySpace, and Second Life, our innate human desire to belong in a community manifests itself in very different ways from those of our ancestors, providing support and interaction in a way they could never have imagined. The emotional need state to connect has remained, but the tools have evolved. As human beings, we continually look for friendships, connections, and links with people, products, and services that share similar values to our own.

Companies such as Coca-Cola have always understood that their customers want to feel a sense of belonging. Its brand has global presence and a global message of sharing and friendship. Starbucks, too, has a similar approach, encouraging the development of a daily ritual, creating a powerful sense of dependability between the product and the customer, who, by buying into the brand, receives the promise of constant pleasure and indulgence.

With every purchase, we evaluate the emotional investment we are making into the brand and the benefits we gain from the experience. As with human friendships, the brands we choose give us a sense of familiarity and comfort, built over time through trust and consistency. We long to be warmed by the love our brand exudes, and if the product gives us what we desire and the brand messages promote an emotionally uplifting experience, slowly and surely our sense of belonging grows stronger.

Are You Talking to Me?

The language a brand adopts—words, messages, and tone of voice—is crucially important in showing an understanding of its audience and in creating a rapport. We all need to be spoken to in the correct manner, so we can respond positively to an individual, and we need to be appealed to and intrigued enough to continue the conversation, once interest has been initiated. Discourse between brand and consumer is no different.

Nike's "Just Do It" tagline gives you permission to tackle tough challenges; it energizes you and inspires you to buy into a slice of the lives of the sportsmen and women who act as its brand ambassadors. Will your putting ability improve by wearing a Tiger Woods cap? Probably not, but you can enjoy walking the walk and talking the talk, sharing in the values of the brand and being part of its success.

L'Oréal tells you to buy its products "because you're worth it." Through this mantra, the company is nurturing your inner confidence, praising your brand choice, and thereby rewarding you for using its products. Creating emotional connections that go straight to the heart, tapping into powerful feelings about self-image, aspirations, and dreams motivates us to buy.

Join the Club

We all want to become members of a club—cementing our sense of belonging by joining like-minded individuals who have made the same brand choices that we have. Ultimately, most of us are creatures of habit. We make a choice and stick with it, unless we are let down. Are you a Coke or a Pepsi drinker? Do you drive a VW or a BMW? Brand aficionados are powerfully enthusiastic about their choices and the pride and certainty they feel in making them. For instance, buying into Apple is more than buying a computer: You are signing up to the brand and what it represents. You are making a statement about yourself. You are probably committing to other Apple products, too, such as the iPod and iPhone. Since the brand's launch, Apple's proposition has been to supply beautifully designed, top-performing technology. This brand promise has stayed consistent, and Apple has delivered on it time and time again. Reward for choosing the Apple brand is belonging to the Apple community. You have now become an Apple person: a smart, savvy, innovative individual (or so the brand would have you believe).

(continued on page 106)

Longing for Brands

The vast majority of consumers can't get enough of the brands they love. Sunday worshiping has been replaced by retail outings, past associations with community leaders, who gave us direction and advice, have been replaced by idolizing football heroes, fashion designers, celebrity cooks, nutrition experts, and home stylists who are all brands in themselves.

The key role for brand managers today is no longer to solely initiate a relationship between customer and product but, more important, to keep the relationship active and fresh. Instilling in the customer's psyche the values and aspirations of a brand is fundamental in creating a strong sense of belonging, a membership that can last a lifetime, if managed effectively.

DIGITAL AUTOMOTIVE SOLUTIONS
The identity and website for autotorq, which specializes in automotive dealership Web services, took its lead from service industry leaders to set it apart from its competitors.

LITTLE GEM FOODSTORE
An identity for this specialist gourmet food store involved a generic logotype versatile enough to be used for different product lines, backed up by stylish photography and illustrations.

BRADLEY BROS WINE
Katie Warner created a contemporary design for Bradley Bros Wine to differentiate it on the shelf, while retaining hints of its heritage and craft.

(EARTH)
partners

science + nature
working in harmony
·······················

ECO
logical!

Clean up for a cleaner world

CPRC
An iconic depiction of parent and
child in circular format represents
the holistic nature of the therapy
offered at CPRC.

MOBILLO
Mobillo is a lifestyle brand created
by a Swiss designer whose busi-
ness encompasses clothing lines,
textiles, and housewares.

40 AGNEW TERRACE
Exclusive properties for an exclusive market communicate
a set of lifestyle values and aspirations that potential buyers
can relate to.

THE EARTH PARTNERS
The campaign identity for The Earth Partners, an amalgama-
tion of scientists and global companies joining forces to
bring about awareness of ecological issues.

Determinant 5

Alchemy and Magic:
Making Life Worthwhile, Wishing Upon a Star

From *Chambers Concise Dictionary:*

Alchemy: *the infant stage of chemistry, aimed chiefly toward transmuting other metals into gold and discovering the elixir of life; a transmitting potency*

Magic: *the art of producing marvelous results*

Disney is the ultimate brand representing family fun with magical experiences for children and adults alike. Disney Clubhouse features activities and programming for children. (Design: AdamsMorioka)

Ancient records show that the peoples of our world have believed in magic for perhaps 10,000 years. From the Stone Age to our current Internet age, we seem to always need it to explain the unexplainable in our natural lives. It was not so long ago—in the late Middle Ages, in fact—that alchemy was considered a serious, if slightly mystical, pursuit of scientific inquiry. Much further back in time, and on the less-serious side, jesters and magicians were to be found in most royal courts and in temporary residence at village fêtes throughout the world. On every continent were formats of one kind or another for soothsayers, fortune tellers, oracles, witch doctors, medicine men, and miracle workers.

Magic has psychological meanings deeply embedded in parts of the brain we still don't fully understand. There is considerable scientific evidence that our need for identity and meaning is hardwired in our minds; it follows that emotional, magical branding has always been an integral part of the human experience. In the increasingly cluttered media environment in which we now conduct our daily rituals, only brands based on deep psychological meaning will prosper. This doesn't mean the product itself needs magic to convince us that it can fulfill a serious physical need. But brands that have the potent mix of alchemy and magic to satisfy both emotional needs and wants will be among the more successful.

Bringing magic into a brand story can transform the trappings of ordinary life with the power of the supernatural. How many amazing feats of cleaning have been accomplished with the powerful help of Mr. Clean or a White Tornado? Of course, the full potential of a creative interpretation of magic and its ability to transport us out of our day-to-day mental coping mechanisms and into a fantasy has not come close to being fully realized. No brand has triggered more entertainment magic than the Disney brand. Magic as a theme and a format can still transport audiences of millions out of humdrum reality and into the wilder reaches of our imaginations. Magic, like alchemy, can turn ordinary products into gold, by elevating the brand image to "gold standard" status. Brand warriors should always think about how to cast a compelling spell on behalf of the brands they work on.

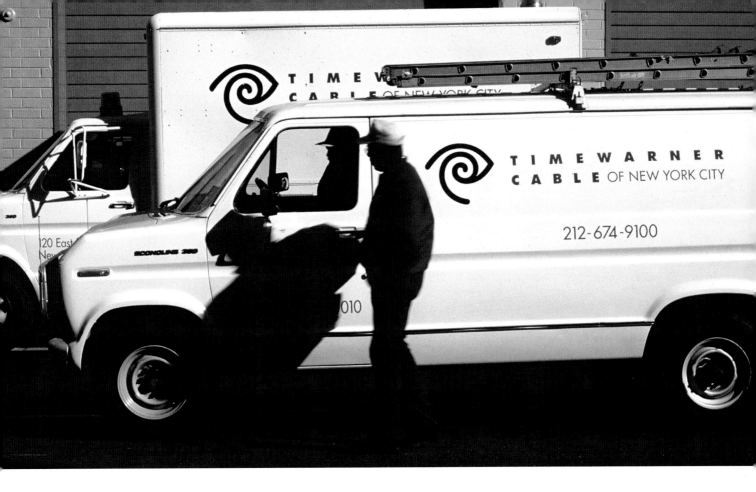

The Time Warner logo was created when Time Inc. and Warner Communications merged in 1990. The newly formed company needed to communicate the essences of each company—entertainment and journalism. The logo is an amalgam of an eye and an ear, the essence of communication. The logo has also become synonymous with the Time Warner cable division. (Design: Steff Geissbuhler, Partner, Chermayeff & Geismar)

The organizations that manage the art of magic for their brands, and have the skills to organize and operate their businesses productively, succeed because they have harnessed the power of defining myths and developed psychologically appealing symbols to support them. The essential objective of any brand communication, be it a logo or a campaign, is to lift a brand (and its product) out of the ordinary. Brand warriors must constantly search for the "transmitting potency" of an innovative idea.

1964

1964: Johnnie on the Spot

In my Cincinnati years at Studio Arts Associates, I absorbed many lessons from my mentor, John Johnson, and made many lifelong friends. Neil Bortz talked me into taking my first trip to Europe in 1964. I quickly rationalized this trip as a research opportunity. My mission, as outlined to Johnson, was to find out what was happening in European design and marketing circles that could be useful back in the United States. So Neil, my wife, and I started in Paris, then went to Amsterdam to see what Heineken was doing. From there, we went to Brussels, where I talked to the P&G people. Then we went to Zurich. While store checking in Zurich, I was amazed at the high quality and sophistication of the private-label packaging at the Migros grocery stores. We moved on to London, and I had the same opinion about the packaging at Sainsbury's grocery store. However, beyond these enlightened examples, I found the packaging design, store promotions, and advertising in general to be below the U.S. standards of the time. By the end of the trip, I had concluded that there were real opportunities in Europe for an experienced American marketing services and packaging company in Europe. More important, I thought this company could be ours!

THECOOPERUNION

The Cooper Union logo reflects the school's art, architecture, and engineering programs. On the website, the logo becomes a moving 3-D object that shifts and moves, showing dimension and space.
(Design: Doyle Partners)

INSTITUTO
artivisão

This is a compelling use of a mobile as a logo for a Brazilian art institute.
(Design: Hardy Design)

Iconicity: Standing Out in the Crowd

KENNETH NISCH, *Chairman of JGA in Southfield, Michigan*

Kenneth Nisch is an architect and chairman of JGA, a retail design and strategy firm in Southfield, Michigan. Named one of the industry's "Most Influential" by DDI (Display and Design Ideas) magazine, Nisch applies his knowledge and entrepreneurial insight into consumer markets to create concept and prototype development, brand image positioning and architectural direction. JGA's clients include Godiva, Yankee Candle, Brookstone, Levenger, Hershey's, the Henry Ford Museum, Greenfield Village, and the Saks Department Store Group.

A strong brand is vital to most businesses today, and that emphatically extends to all retail in this global/local world. The phrase, "Bring the brand to life by creating ideas they can see," really says it all. This is a key priority for successful marketing and merchandising in retail. Each of us is exposed to thousands of impressions a day. The retailer's concern is to create an impression that will be iconic enough to be memorable. While there is truth to the adage that the big will get bigger and the successful more successful, there is also a parallel adage taught to us by biology principles. Just prior to the collapse of any species, it attains its largest presence in size. In other words, the big will get bigger—until they don't.

Today's mega-mergers grab the headlines, but the quiet story is that the largest growth in retail continues to be by the independents. In developing parts of the world, such as Asia, South America, and Africa, retail is still very much an activity between an owner and a customer or the producer and the consumer. This phenomenon is not totally without logic. Who knows the customer better than the person who lives in the community, than the next-door neighbor whose needs and wants are no different from those of his customer?

Independents have a significant competitive advantage, due to their ability to respond "just in time," whether or not they are impacted by the weather or by changing community and social rhythms. When neighboring retailers start a price war, introduce a new product range, or create new, innovative presentation formats, the independent merchant can respond very quickly. The giants find it difficult to achieve this degree of market awareness. It takes intelligence, personal energy, and nerve to be a just-in-time-at-the-right-time retailer.

Our World Is Changing

Today, the contention is that the U.S. and global markets will be made up of a series of "nations," groups that can include the haves and the have-nots, the young and the old, the urban and the suburban. The merchants serving these nations strive to offer an eclectic mix of products to fit the changing desires of their key audiences. I believe that these groupings will create a series of micro-markets, with customers looking for global companies with the best price and the best locations to satisfy their needs: electronics, appliances, and transportation, for example. But for their wants, shoppers will look for a mosaic of suppliers (Internet, catalog, retail) that understand them. Consumers increasingly feel that they define the retailer, not that the retailer defines them. Customers want to hold up a "retailer mirror" and see themselves reflected in that mirror. This is great news for the independent store owners, who, for a variety of reasons, see retail as a form of their own self-expression, as a way to support their lifestyle and interest, and as a way of having a place in their community.

Focus on Iconicity

This is where the concept of iconicity becomes critical. Iconicity involves that "secret handshake" that exists between customer and retailer. The set of code signals that come with iconicity is what creates the bond and connection between the retailer and consumer; it says, "I get you" and "You understand me."

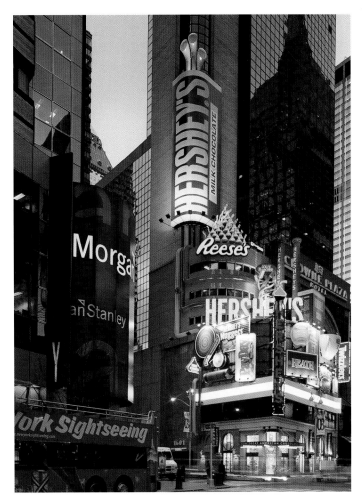

Hershey's, Times Square, New York. The Hershey's brand message of warmth, fun, and nostalgia is brought to life in a whimsical version of Milton Hershey's original chocolate factory. (Design: JGA)

Iconicity is critical in this world of twenty-four-hour news and unfettered access to others. The blur between our time and their time means many of us live a 24/7 lifestyle. Our business, shopping, entertainment, and dining are multitasking efforts of being productive, gaining pleasure, learning, and sharing on an integrated basis. Retail is a byproduct of the need in which the consumer is looking to learn, be entertained, and be delighted, while at the same time experiencing a social connection.

(continued on page 116)

Creating a Unique Identity

Big companies and big chains have, in most cases, failed to create such an atmosphere, a social connection. Successful independent retailers are in effect becoming an environmental blog in which the consumer and the retailer "post" their thoughts of the day in the form of product, communication, and experience. Iconicity can capture the consumer's interest through a layering of texture and complexity to stand out from the hundreds of thousands of impressions that we all receive daily. In the past, we retained between 2 and 10 percent of what we were exposed to. New studies show that, today, we actually recall only a micro-fraction of that amount. What we retain is almost entirely visual; thus, I believe retailers need to create memorable visual experiences.

The brand famously offers a wide assortment of products to a target audience of "Lovers of life and curious thinkers." This identity reaffirms the concept that Borders is an experiential hub for discovering fresh ideas. (Design: JGA)

Iconicity finds its roots in images and experience. It leverages the full sensory palette, from the fragrance the store proprietor is wearing to the freshness of seasonal flowers at the front door and the welcoming smell of coffee being sampled. In this high-tech, high-touch world, it is often the creative presentation of the character and texture of the product that inherently captures and connects with the consumer. I suggest starting with a better understanding of your company's unique assets, whether they are in its personnel, real estate, product assortment, or, last but not least, its customers. Finding the magic to bring together all of these components with a twist of personality is iconic, proprietary, and actionable.

ABOVE LEFT: Reminiscent of a campus, the flow of the natural landscape of this Jaguar dealership in Tampa, Florida, enhances the sophisticated presentation of the cars, and the setting provides a more welcoming, hospitality-based approach to the sales process. (Design: JGA)

ABOVE RIGHT: The eclectic design of the Hot Topic corporate office in California, creates a whimsical, high-energy mix of artwork, passion for the clothing and music product, and an overall pop culture environment. (Design: JGA)

LEFT: The façade of this brash retailer is definitely an "Idea they can see." The message says edgy and iconic, and the postindustrial and loft-like interior continues the illusion of an urban back alley. (Design: JGA)

Determinant 6

Globalization:
The Ultimate War Game

From *Chambers Concise Dictionary:*

Global: *spherical; worldwide; affecting, or taking into consideration the whole world or all peoples*

The word "global," as defined, has a benign, rather abstract feeling to it. "Globalization," however, is a strong catch-all word that describes an irreversible process that has an impact on everything in our lives. Its frequent use in the media ignites tremendous prejudices and starts many arguments. Is globalization good for us? Globalization does help spread the influence of "brands of meaning" and adds to the complexity of doing business globally or locally.

In a meta-economic sense, globalization is essentially the process of global *convergence*. Capital flows to where it earns best returns. Manufacturing goes where costs are less or technology represents the best value. Distribution systems—both bricks and mortar and online—offer a cornucopia of products and services. The world might be dangerous and uncertain, but everyday life is better for billions of people.

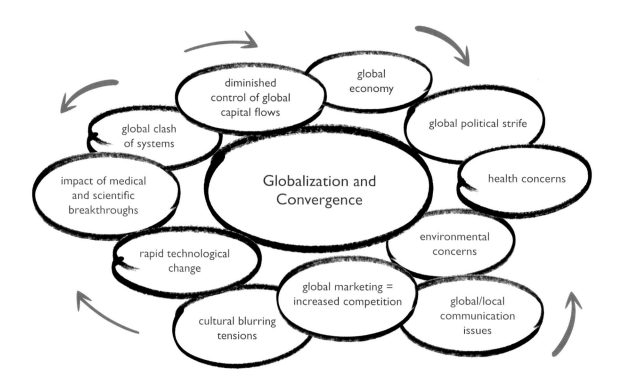

The New York City–based Metropolitan Opera is a globally recognized institution. (Design: Paula Scher, Pentagram; Photo: James Shanks)

The Metropolitan Opera

The Metropolitan Opera

A New Old Paradigm

We are once more living in uncertain times, and in a societal persuasion context, history may well be repeating itself. We are again in one of man's oldest forms of conflict: a global struggle between "belief systems," this time with Islamic terrorist groups basing their hatred on an extremist version of traditional Islamic faith.

As we sip our Starbucks, we can't escape the reality that we are all now indisputably caught up in competing societal persuasion campaigns. Al-Qaeda and other forms of extremism, confronting us under a variety of names and branded identities, are perhaps this age's ultimate example of *negative* emotional branding. The rhetoric is harsh, and the product promise is fear, death, and destruction. There is no targeting of hopes (and certainly not much in the way of managing our fears) from this fanatic societal persuasion brand.

But there is some good news. An increasing number of well-organized and well-funded branded campaigns are beginning to focus on global wars to wipe out poverty and eradicate hunger and disease. Creative brand warriors have an obligation to help clients very publicly address the issues that threaten our world.

Global organizations that manage the biggest and most influential commercial persuasion brands can lead the way by their actions and through well-targeted branding campaigns. The brand message must truly be based on targeting hopes and managing fears.

The Martell cognac packaging aptly reflects its elegant and luxurious positioning worldwide. (Design: Dragon Rouge)

The Lipton brand, symbol of quality on many products, is probably the most famous tea brand in the world today.

The internationally known Black & Decker brand always promises "tools" that get the job done well. (Design: Sterling Brands)

1966

1966: The Mayflower Sails Back

A year and a half after my first research trip to Europe, I wrote what passed as a business plan for establishing an office in London. We asked the British designer, Michael Peters, who was working at the CBS network headquarters in New York, if he wanted to join us in London. Johnson remained in Cincinnati as the president of Studio Art Associates, the parent firm of the new, fledging London office.

After more discussion and a lot of planning, Peters and I, along with designer Dick O'Brien, set sail for the United Kingdom on a sort of reverse migration. The announcement of our imminent arrival, sent to an extensive mailing list, was an American flag folded into a paper boat. The copy was "Cato/Peters/O'Brien have set sail for the United Kingdom." It worked. People remembered this and were curious enough to see us. (This was my first multinational direct marketing program.)

We hit the streets, presenting to agency art directors, publishers, and marketers. It was the right time. London was swinging, and change was everywhere. Our U.S. experience seemed to be valued, but mostly we reinvented ourselves to match the opportunities. We did book jackets and record covers and covered all our contacts and recommendations like the proverbial wet blanket. I hounded P&G in Frankfurt, Paris, Geneva, and Rome with some success. The main effort was in Brussels, where Vernon Rader, a friend and client from P&G, was now in charge of European packaging.

We had set out to be an international, not just an English, design and marketing services firm—and we had done it. Within a year Peters left, eventually starting several different design businesses.

World War II was the defining event of my childhood, and films about the Asian part of the global conflict always portrayed the Chinese as stalwart allies. Not much later, I was aware that the old order was gone and the new government of Mao was in. For many years, China was at odds with the entire Western, non-communist world. Information was sparse, but stories about the Great Leap Forward and the turmoil and upheavals leaked out. The country seemed more foreign than ever. My initial trip to Hong Kong in the early 1970s provided a real sense of the Chinese people. I recall going to the edge of the New Territories, gazing past the fence into mainland China and wondering if I would ever get past the political barriers and see the real thing.

In 1983, the gates opened for me. The Chinese government invited an international design association to come and speak about packaging. We all developed written and visual presentations, which were translated and sent ahead. The group arrived in Beijing sometime in the middle of the night and was taken in buses to a scene straight out of an old movie. In the dim light, we could see the profile of low structures, in traditional Chinese architectural style, surrounding a pond spanned by an arched bridge. Each of us ended up in a dazzling nineteenth-century apartment—and learned the next day that we had been quartered in the former state apartments of the old Summer Palace.

Thus began an incredible journey. We made presentations in small and grand places, always treated with courtesy and rapt attention. We always traveled by train (there was no civil aviation then), from Beijing to Shanghai, on to smaller cities, and even to a village near a printing works. Here we were, in a China that had just "opened," and I don't know who was more curious—us or the staring crowds we drew. For decades, essentially nothing had changed in this enormous country. I felt like an explorer in a very foreign place—and enjoyed every minute of it. On a great overnight train journey, we all stared out the window at rural landscapes unseen by foreigners for almost forty years. Even then, we knew this ancient civilization would regain its stature as one of the most dynamic and important nations in the world.

On my next visit, in 1995, the cities and the countryside were almost unrecognizable. I had the opportunity to talk with both long-time expatriates and young Chinese business people—some educated in the United States—who were making their mark in the New China. China had stepped across the threshold to the future, and it wasn't looking back.

The Chinese designers and educators, whose words appear on the following pages, demonstrate that China's continuing, dynamic business growth will be aided immensely by its burgeoning design community.

YANLING WANG, *Assistant Professor of Design at the College of Architecture, Design, Art and Planning (DAAP), University of Cincinnati*

Yanling Wang grew up in Guanghzou and studied in a unique five-year program of product design, architecture, interior design, landscape architecture, and car design at Tongji University in Shanghai. She returned to Guanghzou for a master's degree in product design at Guangzhou Academy of Fine Arts and worked as a professional product designer at Formstudio. With Professor Huiming Tong, she wrote the book *100 Product Designers in 100 Years*. In 2005, she earned a master's degree in graphic design at Iowa State University. Currently, she is an assistant professor in the College of Design at the University of Cincinnati's College of Design, Architecture, Art, and Planning (DAAP).

In 1978, China outlined the Four Modernizations policy, marking the beginning of China's reform era. A lot has changed since then, at an astonishing speed and in all dimensions. China has become a factory to the world, a vital part of the global supply chain, and "Made in China" has become a familiar label on many products. Unfortunately, too little is known about the creative energy that has been unleashed in contemporary China. Over the last three decades, the Chinese design profession, starting with the early pioneers of design, has been constantly developing ways to accommodate, reflect, and inspire the contemporary Chinese lifestyle. For generations, the Chinese creative profession has been striving to establish its unique identity and is now creating a design language that is becoming a factor on the international stage.

In the following pages, I have tried to capture the changing landscape of the Chinese design profession by introducing and interviewing four designers of three generations.

HUIMING TONG, *Dean of the College of Design, Guangzhou Academy of Fine Art and Vice Chairman of the Guangdong Industrial Design Association*

Huiming Tong is dean of the College of Design at the Guangzhou Academy of Fine Art (GAFA) in Guangzhou, China; a member of the Industrial Design committee at the China Artists Association; an executive member of the China Industrial Design Association; and vice chairman of the Guangdong Industrial Design Association. Huiming has been active in both design education and design practice and is the author and editor of six books and more than 200 articles.

Q: As a designer for more than twenty years, what changes have you witnessed? What impact have the changes had in the design profession?

A: Twenty years ago, I pessimistically predicted that it would be another twenty years before the Chinese design industry blossomed, basing that assumption on the neglect, at that time, of industrial design in society. I was right; it was 2006 before we saw the real turning point. Six major changes have occurred in the last twenty years.

1. Design practice by academia to design practice by the professionals. The demand for modern design in the early 1980s did not come from industry. It was introduced in design schools with a focus on design history and theory, rather than on practice. The first design firms emerged in the early 1990s in Guangzhou, Shanghai, and Beijing. A few years later, in-house design departments started to emerge in companies such as Midea, Lenovo China, and Haier, along with more professional design firms.

2. A move from innovation led by design firms to innovation led by in-house design. In the twenty-first century, in-house design departments have demonstrated better design capability than most of the consultancies. Large Chinese enterprises now rely mainly on their design departments and only consult with international design firms for conceptual designs.

3. Design activities have become increasingly international. There are more international designers active in China and more design events. Chinese designers are now winning international awards, and more design schools are building international connections.

4. A rapid improvement has occurred in design quality. More Chinese products offering unique quality, not just low prices, are entering the international market. More and more Chinese designers have been promoted to managing positions in design centers of top international brands, and these designers are now sweeping international design competitions.

5. Independent Innovation is a national policy, and many of China's east coast cities have adopted new strategies to develop the creative industry. Governors in cities such as Beijing, Shanghai, Guangzhou, and Shenzhen have focused high-profile attention on the creative industry, and various creative industry parks have emerged. All have helped to increase the awareness of design and innovation.

6. Brand awareness is awakening. The Chinese manufacturing industry has grown from OEM (Original Equipment Manufacturer), playing the role of factory to the world, to adopting advanced manufacturing technologies and modern management. Brands such as Apple, IBM, Canon, and SONY, with their high standards, have been placing orders for manufacturing in China. The old image of poor-quality Chinese products is gone, and more enterprises are building their own brands.

Q: With the growth in the Chinese design industry, will there be more branding design for exported Chinese luxury goods?

A: International luxury brands predominantly entered the Chinese market in Beijing and Shanghai. Chinese manufactures have seen the great potential of this market, but, thus far, luxury goods consumers have faith only in European or North American brands. As a result, Chinese enterprises have been purchasing and repackaging lesser-known brands from Italy, Switzerland, and other Northern European countries. Currently, many high-end fashions, watches, furniture, and stereos, claiming to be made and designed in Europe, are [manufactured by companies] owned by Chinese investors. It will take time for Chinese luxury brands to be accepted in both domestic and international markets.

Q: How should Chinese enterprises create their own brands? What's the role of Chinese designers in the process?

A: Strong brands must have strong innovation teams to consistently produce meaningful products and services. For example, Echon in Guangzhou, created by a group of industrial designers to provide design and manufacturing services for the television industry, has served brands such as Haier, TCL, Konka, and Skyworth. With an integrated approach in design and manufacturing, Echon has led and shaped the Chinese television industry. Echon's approach might be the most practical and appropriate model for other manufacturers to follow.

(continued on page 128)

Brands such as Apple and Nike focus on internal design innovation and branding and contract their professional manufacturing services externally. In the near future, a large number of local brands will follow the same model, with Chinese brands in many product categories gradually entering the world market. Enterprises in China that run large-scale OEM businesses have been losing their competitive advantage, principally because they do not have a strong brand presence. For Chinese designers, this is a good time; future development will shift from solely designing a product to establishing the meaning of a brand and building a design strategy.

Q: In an overall sense, where or in what direction will the Chinese enterprises and design firms grow?

A: The change from "Made in China" to "Designed in China" is the goal of not only the government but also of the enterprises. A similar transition happened in Japan in the 1960s and '70s and in Taiwan, South Korea, Singapore, and Hong Kong in the 1980s and '90s. The same pattern is now being repeated in China. The country will establish a unique identity by reexamining Chinese culture, history, and tradition.

Products designed by Tong Huiming

LU YONGZHONG, *Chairman of VEP Design Associates and Founder/ Chief Designer of Banmoo, Shanghai*

Lu Yongzhong is a lecturer of art and design in the College of Architecture and Urban Planning at the Tongji University in Shanghai, China; chairman of VEP design; and founder and chief designer of Banmoo furniture and accessories. With a multidisciplinary education background, Yongzhong has been active in the fields of architecture, interior design, product design, visual communication, and branding. Established in 1997, VEP design has grown into the most influential design firm in Shanghai, with more than fifty employers working in three departments: space, brand, and exhibition. Its clients include Motorola, L'Oréal, Kodak, Hotel Hyatt Regency, Louvre Museum, Pompidou Center in Shanghai, Cheng Congzhou Museum, Shanghai Art Museum, China Telecom, Dragon TV, and the Jinmao Group.

With the passion and ambition to bring traditional Chinese culture to life, Yongzhong founded BANMOO furniture and accessories in 2006. It is his intention to establish a brand that strives for harmony between Chinese tradition and modern design, and the integration of handcraft and new technology.

Q: With the tremendous success of VEP design, what triggered you to develop the Banmoo brand?

A: Simply put, my intention was to develop a brand that accommodates the contemporary Chinese lifestyle. I went to Europe and saw many design stores and brands; the Western ones and those from Asia that combine the traditional and modern. However, exported Chinese furniture was limited in style to either Ming or Qing Dynasties; they were imitations of the traditional styles and were sometimes poorly done. I connected with skilled Chinese manufacturers and craftspeople and worked with them to design and develop furniture and home accessories. When I felt I was ready, I opened the Banmoo store.

Q: How did you come up with the name Banmoo? What's the story behind it?

A: The word Banmoo literally means "half wood." Wood has played a key role in the lives of the Chinese for more than 2,000 years. We live in it, eat with it, sit on it, and sleep in it. But I wanted to explore the Chinese philosophy of pursuing "half," instead of full or packed—the goal is to imply, to hint, to provide room for imagination. The word "Banmoo" sounds as if it comes from traditional Chinese literature, yet it is the language of modern China. People can associate it with many different things.

Banmoo is a Chinese brand that inherits the essence of Chinese tradition and culture and adapts it to a contemporary urban life style. I want to reveal the nature of the materials, with restrained and minimal design, to evoke imagination and enjoyment. Many people in the Orient have a tradition of pursuing simplicity and humility. It is time for us to ponder, to reflect, and to revalue some of things that we have lost in the nationwide pursuit of economic growth, something that is higher than materialism.

Q: How did you communicate and establish the brand image of Banmoo?

A: Mainly through the consistent design language for Banmoo products and my Banmoo store. I have designed a range of furniture, jewelry, and home accessories, and my goal is to promote the Banmoo lifestyle through the products. They should speak for themselves and interact with the consumers.

Q: How does your firm compete for business? What's the strategy for promoting Banmoo? What about branding design done to compete in international markets?

A: At VEP Design, my job as a design consultant is to first gain an understanding of the consumer and then develop design solutions for the clients. Through years of working with various clients, I understand how much work it takes to build a brand. However, when it came to Banmoo, I worked more like an artist. I began with an idea, a personal philosophy, then introduced products into the market, received consumer feedback, made adjustments, and built more.

Until now, we have advertised Banmoo through a website, a blog, a printed booklet, and by attending exhibitions, such as the Get It Louder 2007 exhibition in three major cities: Beijing, Shanghai, and Guangzhou. I'm still finding my way; businesses like Banmoo are rare in China, and there isn't really a model that we can learn from. Instead of thinking about competitors, I am more concerned with the creation of good products. To compete successfully in the international market, I believe we need to first create our own unique voice. Banmoo is a true Chinese brand, and I will proudly promote it as one.

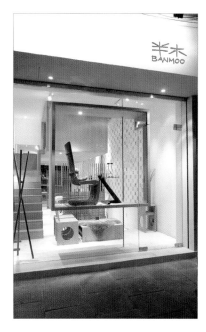

The Banmoo retail store

Q: Does Banmoo aim at a specific audience? From what you know, who are the actual consumers of Banmoo products?

A: The market has become more and more segmented. People are looking for something with unique characteristics. This is what I am relying on—the pleasure of interactions between the designs and the consumers. Banmoo has drawn lots of foreigners. Some have told me they see elements of Scandinavian or German design in the products. Everyone will have his or her own interpretation of Banmoo products. Our best customers are those who appreciate the oriental culture and prefer products with a unique personality. Happy customers have become our voluntary advertising agents.

Q: In an overall sense, where, or in what direction, will Banmoo grow? If you could look into the future, how would you describe your firm in five years' time?

A: Building my own brand is very different from my job at VEP Design and much more complicated. My plan is to first build a framework and, in the process, learn to evolve. When the business, and the brand, grow bigger in the future, I will certainly seek collaborations, nationally and internationally, and focus more on branding and marketing.

The Banmoo store interior

(continued on page 132)

Q: How will the overall Chinese creative community develop, given all the growth in China? Will more branding design be done for mass distribution of Chinese products? For exporting luxury goods?

A: Things have changed dramatically since China opened to the outside world almost thirty years ago. Designers and artists have gained lots of information through various channels. They have learned a lot from studying the work of world-class designers, including those who worked in China. Chinese designers have become more sensitive to their own culture by asking themselves, "what is my design language; what is my design system; how do we see our own culture?" I call it the Chinese renaissance.

I believe that, in the future, more branding design will be done, both for Chinese products for mass distribution and for luxury goods for export. It will take time. A lot of manufacturers develop products and negotiate the use of a known brand name, or use an exotic brand name, because they lack confidence in a Chinese brand. Some of my friends have said that I should give Banmoo an English name. But it is a Chinese brand that I want to build, and I believe people will have more faith in Chinese brands in the near future.

Waterfall screen

You and Me candle stand

Full Moon incense stand

Spring music box

Illustration of Spring music box

Fusiform vases

Salt and pepper shakers

Nesting tables

FAN ZHANG, *Industrial Designer at Mercedes-Benz in Germany*

Born in 1975 in Sichuan Province, Fan Zhang is probably the first Chinese car designer to work for an international brand without formal education and work experience abroad. Zhang received his bachelor's degree in industrial design at Tongji University. When working on his graduate project, Zhang designed a small car for family use in China, with guidance from German designers Klemens Rossnagel and Marion Kiessling. His first taste of car design was inspiring and led him to pursue a master's degree in industrial design, with a focus on transportation design, at Tsinghua University, Beijing, China. With Professor Liu Guanzhong as his primary professor, Zhang submitted his work to international competitions and won many awards over the three years of his graduate study: First Prize in the Mitsubishi Motors International Design Competition 2000; Bronze Prize in the China Motor International Design Competition 2001 (Taiwan); and Best Branding Prize of *Auto Motor und Sport* International Design Competition at the Pforzheim Transportation Design Forum 2002.

For the *Auto Motor und Sport* International Design Competition, each participant was asked to propose a concept for a new vehicle brand uniquely suited for their country. Zhang's design and presentation of the new Chinese vehicle brand, East Scene, was well received. He was offered a job at the Mercedes-Benz Car Group, Daimler AG, Germany, as an exterior designer shortly after the competition. Over the past six years, Zhang has been working on many Mercedes car projects and has grown into a skilled car designer. A production car that bears his own design will come out to market in the next few years. Following is an interview with Zhang.

Q: Can you tell us your thoughts when designing East Scene in 2002 as a new vehicle brand for China?

A: In the past, China did not have a strong car culture or car heritage. The Chinese are not keen at all on the engineering or racing aspects of automobiles. Instead, it is the space they live in that matters most, and it is a tradition in Chinese culture to think about space philosophically. In that sense, a car is a moving space, and I wanted to design a Chinese car brand that reflects Chinese culture, context, and custom, and the Chinese way of car styling. I wanted to forget about all the previous Western influences of car design and tried to envision what would have happened if the car was invented in China a hundred years ago. The logo I designed for the brand has a dynamic S shape that was inspired by the yin and yang symbol. It looks Chinese but with a modern impression. I also tried to apply some Chinese motifs or symbols into the exterior design of the car and something different from what you would see daily on the street. I think the juries noticed that and gave me a very positive response.

Q: What would you do differently if given the same assignment now?

A: I would follow a similar approach for the brand design but extensively revise the exterior design. As a professional car designer, I have learned to design and judge cars not only by details or elements but, more importantly, by proportion, stance, and surface language of the car. Looking back at East Scene, I would have to say it was very amateurish. I can do so much better now.

I still believe the branding design ideas I had are brilliant. Those are things the Chinese carmakers should seriously think about; I believe they could lead them to a style that suits the massive Chinese market. Of course, those ideas are very basic and raw, but I believe they have great potential. The Chinese market is changing, but it is not beyond my vision of six years ago.

Q: What are your observations on the Chinese car design industry? Have there been any changes since you left in 2003?

A: I follow the development of the Chinese car design profession mainly via the Internet. I know that many car design studios have been established, design students have an easier time getting good jobs, and carmakers are more and more aware of the importance of design. They are investing in the development of new styles for production cars and are even developing show cars. Some companies have set up design studios overseas and hired American and European designers. But I think most companies are still too cautious to give Chinese designers enough authority to lead the market. Although there have been great changes since 2003, I believe the best is yet to come.

ABOVE AND RIGHT: **Caeser model**

RIGHT: **Noah model**

RIGHT AND BELOW:
Car renderings

ABOVE AND LEFT: **Sketch of Cooldeer and full model**

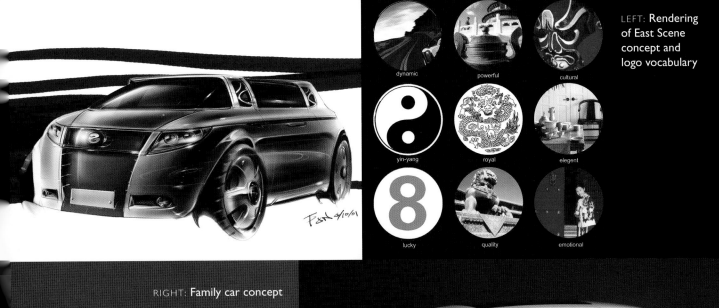

LEFT: **Rendering of East Scene concept and logo vocabulary**

dynamic powerful cultural

yin-yang royal elegent

lucky quality emotional

RIGHT: **Family car concept**

TOM CHUAN SHI, *Industrial Designer in China*

Born in 1974, Tom Chuan Shi is a rising star in the Chinese creative community. He earned his bachelor's degree in industrial design at Guangzhou Academy of Fine Arts, Guangzhou, China, in 1998. A student of Professor Tong, Shi worked in Formstudio and designed consumer products for the Pearl River Delta Region enterprises until 2003. As an idealist, Shi was not satisfied with what he could accomplish, especially because design was not fully appreciated by local enterprises. He left China to pursue a master's degree of industrial design at Central Saint Martins College of Art and Design in London. Working with two young Chinese designers, WeiWei He and Jody Wenying Lu, Shi developed the witty design for the Dog Poo Spray. The trio won the D&AD Student of the Year Award in 2005 and was listed in Design Week's "Hot 50 people making a difference in design 2005."

After receiving his degree in 2005, Shi stayed in London working in product and brand design, then returned to Guangzhou and established TomShi Studio in 2006. With all the changes and new opportunities in China, Shi spends one-third of his time working with clients on product design, one-third on the development of new Chinese brands with friends, and one-third on experimental designs. He continues to win awards, and his work has been featured in national and international journals and exhibitions.

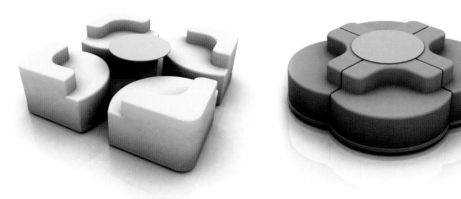

Flower-shaped furniture

TreeHouse

Fashion phone

Pooproof Spray

Determinant 7

Curiosity:

Looking Under the Rock

From *Chambers Concise Dictionary:*

Curiosity: *anxious to learn; inquisitive; singular; rare; odd*

Truvia is a natural sweetener made from the stevia plant. The brand design reflects the natural ingredients. (Design: Paula Scher, Pentagram; Photo: Jessica Walsh)

7

Successful creatives are curious souls. Brand warriors have a desire to figure out what things really work and why, in different markets and in different countries. All the innate creativity in the world isn't enough.

Even with an array of new communication tools, successful brand warriors stick to the basics and ferret out the psychological needs potential customers have in common, despite obvious cultural differences. By digging deeper, into "what lies beneath" (see chapter 5) in the minds of a target audience, the curious creative warrior can find the hidden connection to the consumer that has thus far eluded the brand's stewards. But when this happens, be careful. Without a ton of collaborating data, this new "big idea" might not be received with universal acclaim on the client side.

Thinking differently is what you get paid for, and standing up for what you believe is a good criterion, if you aspire to be innovative and promote daring ideas to clients. In jousting with the absolute power of clients, you must accept that sometimes you win, and sometimes you lose—but mostly you compromise. It's always worth battling when you are convinced that a proposed, well-thought-out strategy, backed by an innovative, creative idea, will do the best job of stimulating the curiosity of the target audience, whose attention the clients are trying to attract.

Human curiosity has fueled virtually all of the world's great discoveries, led to the greatest inventions, and prompted our greatest cultural achievements. And man's spiritual curiosity is, I cautiously suggest, the sustaining appeal of our most enduring societal persuasion brands. The great majority of commercial persuasion brands also depend, to some degree, on the innate curiosity of the consumer. New products introduced under the banner of a new brand, and supported by advertising and promotion, focus on stimulating the curiosity of the consumer and sparking sufficient interest to motivate the sale. Therefore, making the consumer aware of the new benefits of a new model of car, camera, or can of soup, and then motivating them to buy, is a high priority. In many categories, the designer's first creative task is to design the kind of packaging that will first arouse the consumer's curiosity, then to stimulate interest, and finally to motivate purchase. When retail outlets allow marketers to place promotion or merchandising materials, the brand warrior must pull out all the creative stops and spark the consumers' curiosity long enough for them to consider the brand's persuasion argument.

New products, even those that are logical brand extensions, require a lot of persuasive selling to be accepted by the consumer,

RIGHT: Logo for a new wine bar called Vino Téque (Design: Evenson Design Group)

BELOW: This famous Asian beer brand was redesigned for introduction into new venues and new packaging formats. (Design: DesignBridge)

whether the product (or service) is an every-day or special-day purchase. Ultimately, the cycle of trial, repurchase, and then making it to the consumer's short list of preferred brands will decide the success or failure of all products. Make no mistake, consumer curiosity is a powerful brand consideration tool. Creative brand warriors, therefore, must themselves always be curious. This is particularly important when they are engaged in creative brainstorming, alone or in a group, about ideas that will visually tickle the fancy of the congenitally curious consumer.

Like most curious brand warriors, I seek the famous Unique Selling Proposition (USP) of every brand I work with. But I also search for the Unique Sensory Perception of a brand, which is, for me, still the equivalent of the search for the Holy Grail. We may never pin it down for long, because changing times can require changing concepts, but promoting the brand's core sensory appeal remains the best way to answer the consumer's curiosity about the product. The appeal might be texture, color, touch, aroma, sound, music, a distinctive shape, or a combination of these.

Cato Associates led an extensive S.E.N.S.E. research and creative program to help persuade the Johnnie Walker brand's worldwide managers of the need for a compelling global brand positioning and a comprehensive communications program.

1974: The Price of Growth

Cato Johnson was doing well; we were hungry to expand further but couldn't afford to do it on our own. Smallish creative companies weren't a high priority for small investors, we had not found any suitable partners, and banks were not the answer. So, in 1974, we started thinking about approaching the advertising agency world to see what interest we might find.

Because P&G was our most important client in Brussels and Cincinnati, and to a smaller degree, in London, I asked Jim Tappan of P&G to float the idea of a merger with his contacts within the tight P&G agency network. At that time, the most likely were Benton & Bowles, Grey, and Y&R. Word came back that both B&B and Y&R were interested in meeting with us.

Mike Hickey, who was now running the Cincinnati and New York offices (John Johnson had curtailed his management activities and opened a small CJ office in San Francisco), Gerry Postlethwaite in London, and I were involved in the early discussions.

We talked a lot about what we might be getting into. All of us were under forty and still ambitious, and what we wanted most was sufficient investment to develop and grow our international business. If we had to sell all or part of our business, then we needed to be very clear about our goals and what a large international agency could offer.

We agreed on the following four key needs/wants.

1. Access to new geography and new markets for potential CJ expansion.

2. Access to capital for such expansion.

3. Access to an agency's important international clients.

4. Access to knowledge and skills we did not have.

We also wanted to continue to run the CJ business, and the financial terms of any "merger of interests," as we so naïvely expressed it then, would include participation for key CJ people within the agency's equity structure.

Another critical factor was—and this was truly naïve— that if a merger didn't turn out the way we wanted it to, we could buy out our partner.

I also urge you to always be curious enough to dig a little deeper for the brand's key Unique Emotional Positioning (UEP). I've emphasized throughout this book that it is the likeability of the brand's personality or character that subconsciously sets the stage for a purchase decision. With brands we like, we are always curious about the latest installment of the brand story. The brand positioning chart on the following page, proved extremely valuable to the brand's custodians worldwide.

Johnnie Walker–branded products and retail location concepts created by Cato Associates in 1998.

Opposite page: Johnnie Walker brand positioning chart

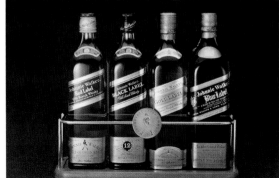

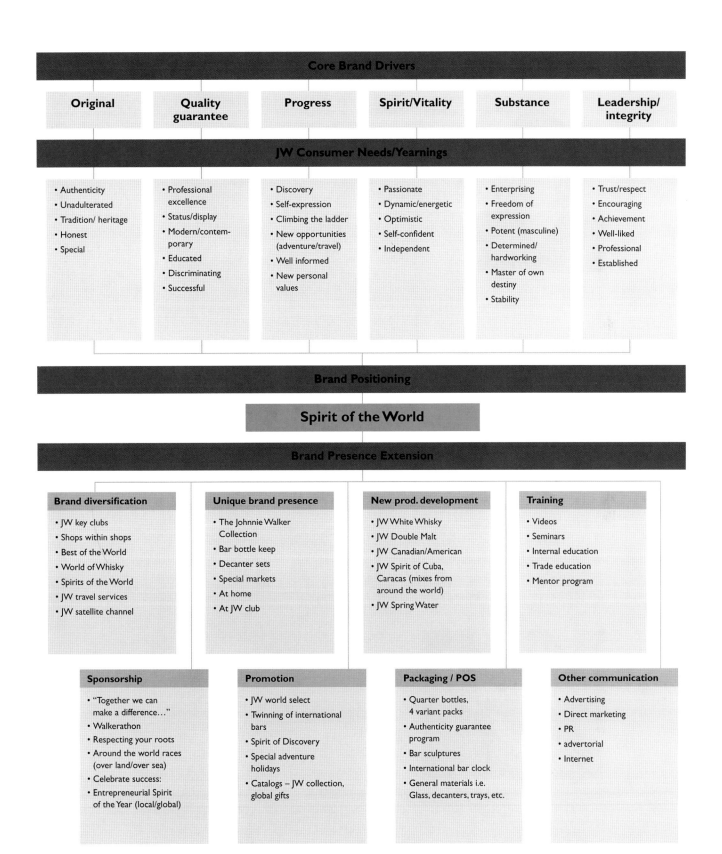

Core Brand Drivers

Original	Quality guarantee	Progress	Spirit/Vitality	Substance	Leadership/integrity

JW Consumer Needs/Yearnings

• Authenticity • Unadulterated • Tradition/ heritage • Honest • Special	• Professional excellence • Status/display • Modern/contemporary • Educated • Discriminating • Successful	• Discovery • Self-expression • Climbing the ladder • New opportunities (adventure/travel) • Well informed • New personal values	• Passionate • Dynamic/energetic • Optimistic • Self-confident • Independent	• Enterprising • Freedom of expression • Potent (masculine) • Determined/ hardworking • Master of own destiny • Stability	• Trust/respect • Encouraging • Achievement • Well-liked • Professional • Established

Brand Positioning

Spirit of the World

Brand Presence Extension

Brand diversification	Unique brand presence	New prod. development	Training
• JW key clubs • Shops within shops • Best of the World • World of Whisky • Spirits of the World • JW travel services • JW satellite channel	• The Johnnie Walker Collection • Bar bottle keep • Decanter sets • Special markets • At home • At JW club	• JW White Whisky • JW Double Malt • JW Canadian/American • JW Spirit of Cuba, Caracas (mixes from around the world) • JW Spring Water	• Videos • Seminars • Internal education • Trade education • Mentor program

Sponsorship	Promotion	Packaging / POS	Other communication
• "Together we can make a difference…" • Walkerathon • Respecting your roots • Around the world races (over land/over sea) • Celebrate success: • Entrepreneurial Spirit of the Year (local/global)	• JW world select • Twinning of international bars • Spirit of Discovery • Special adventure holidays • Catalogs – JW collection, global gifts	• Quarter bottles, 4 variant packs • Authenticity guarantee program • Bar sculptures • International bar clock • General materials i.e. Glass, decanters, trays, etc.	• Advertising • Direct marketing • PR • advertorial • Internet

Design Sense

KENNETH HIRST, *Principal of Hirst Pacific in New York, New York*

Kenneth Hirst is principal of Hirst Pacific, a global product design company headquartered in New York, New York. Hirst is a leading innovator in product, corporate identity, branding, and architectural design.

P roduct design and understanding how a brand's persona influences consumer choices have been major influences in my development of products and brand strategies over the past two decades. Following are snapshots of this evolution of product design with branding.

After discovering industrial design at Canberra University (formerly CCAE), Australia, in the late 1970s, I quickly developed a passion for designing products. It was thrilling trying to make a better "mouse trap" with a modish new style. I drooled over books and publications depicting the futuristic designs of Luigi Colani and Syd Mead, who have influenced much of the contemporary design we see today. My life, my image, and my brand were being molded by this infatuation for good design. The only important thing to me at the time was to design a great product and have it made well, because, in my mind, that's all it would take for a product to sell like hot cakes. It was that simple. Or was it?

Oral-B packaging and new brand identity system

By the mid-1980s, I found myself in New York (where I have been based for the past twenty-two years), working as a design consultant for large American corporations such as Estée Lauder, Gillette, PepsiCo, and Exxon, to name a few, and later for companies in both Asia and Europe. Back then, in New York, great design alone was no longer the most important consideration in a creative assignment; a design that exuded the brand personality and attributes and would ultimately influence the psychodynamics of the target consumer

was required. Brand strategy was gradually being woven into how I approached product design. However, the battle for me in those early years was about bringing the brand to life through the design of the product, without compromising truly great design. Strategically created solutions that fit the brand personality do not always become classic icons of design, so blending strategy and "design" as a single principle was an essential next step. As a result, the synthesis of the two disciplines, brand strategy and product design, was underway.

All powerful and influential brands are built around exceptional products and services. These products and services help define the subliminal idiosyncrasies of the brand and why they appeal to all of us. An ice-cold, fizzing Coca-Cola, for example, will always refresh and quench a parched throat, and Apple's digital innovations will always be encased in cool, clean design. These brands join many others that have crossed international boundaries and are truly global, with products and brand identities that appeal to a broad ethnic diversity in all cultures.

Absolute Essens, an Estée Lauder fragrance prototype

The Power of Persuasion

On one occasion, I was engaged in a global project for PepsiCo prior to Iraq's invasion of Kuwait in 1990 and the subsequent Desert Storm. The project was to review Pepsi's global outdoor presence and then determine new initiatives and opportunities. The part of the world I was to investigate included Saudi Arabia, United Arab Emirates, and Kuwait. At the last minute, Kuwait was cancelled from the itinerary, and, at this time, Americans were advised not to travel in the Middle East. I became the lone sacrificial Australian to audit the region.

My flight from New York via London to Jeddah, Saudi Arabia, arrived at about 11 o'clock in the morning. Prior to landing, I noticed the airhostess giving out handfuls of little liquor bottles to most of the Arab passengers; she asked me if I would like four miniature Johnnie Walkers. I was puzzled by the frenzy to

(continued on page 150)

Hirst Pacific's orbit clock maps the position of the sun chronologically.

consume as much alcohol as possible at this early hour in the day. I then recalled that the Kingdom of Saudi Arabia, with its predominantly Muslim population, was a strictly alcohol-free state, which made the on-board guzzling understandable.

At the hotel, I rested, readied myself for the audit, and that evening decided to dine at one of the hotel's international restaurants. I chose the Japanese restaurant, where, to my surprise, beer was listed on the menu. I immediately thought that this, an international businessman's hotel accommodating the foreign businessman, was a sanctioned oasis, within whose walls alcohol could be consumed by non-Muslim travelers. Excited and without hesitation, I ordered a Swan Lager imported from my homeland. After consuming my second beer and almost through my meal, feeling happy, I ordered another. A few sips later, I began to feel a little tipsy, most likely induced by a hint of jetlag. With little to do and no distractions, I started to flip the can around, studying the black swan logo and the red, black, and gold color palette. Gradually, as I worked my way around the can, reading the contents, I discovered the words "Non-alcoholic Beer." My god! I was three sheets to the wind drinking non-alcoholic beer?

The power of persuasion, the brand name, and my memory as a youth growing up in Australia, where consuming as many beers (with alcohol) as you can in the shortest amount of time was a way of life, had influenced my psychological euphoria. Embarrassed and a little flushed from consuming too much—or too little—of this non-alcoholic beverage, I staggered back to my room to sleep it off.

Shaquille O'Neal
Limited Edition
basketball timepiece

Creativity

The numerous cultural experiences I have had, along with being active in a global arena, have honed my intuitive approach to design. It is the experience that generates thought, and it is the continuous process of pondering these thoughts that produces a bounty of ideas, sometimes brand-new ideas and, at other times, a next-generation appropriation or adaptation. Creativity, an intangible gift, brings to life figments of an active imagination. Imagination is boundless and, like the universe, is always expanding. The talented are able to instinctively grasp and bring order to the essential parts spiraling outward from our imagination's reversed vortex that ultimately form an idea. Understanding this with an open mind allows me to create a diverse range of commercially persuasive brand identities and patent-protected products in a broad range of categories and design disciplines. A few examples are presented here.

Smartlytes, a low-heat, low-energy light source

Deception, one in a range of proprietary fragrance protoypes

JO ROBBINS
SKIN ARCHITECT

SUPER SKIN
OPTIMIZER

MICRO PEPTIDES
+
GLYCOPROTEINS
+
CERAMIDE 3A

JO ROBBINS
SKIN ARCHITECT

REVITALIZING TREATMENT
CLEANSER

AHA + E + A

$\text{ml} \, e \, 6.7 \text{fl.oz}$

JO ROBBINS
SKIN ARCHITECT

EXTRACELLUL
LIFTING SERU

MICROALGA EXTR
+ SESAME + M

15ml e 0.5fl.oz

JO ROBBINS
SKIN ARCHITECT

CELL DEFENCE DAY

SUPEROXIDE DISMUTASE + E + MSM

$50\text{ml} \, e \, 1.6\text{fl.oz}$

Determinant 8

Entrepreneurship:

It Is Personal, and It's Not *Just* Business

From *Chambers Concise Dictionary:*

Entrepreneur: *a person who undertakes an enterprise, esp. a commercial one, often at personal financial risk.*

This line of innovative skincare products is named after its founder, Jo Robbins. The product reflects the person. (Design: Absolute Zero Degrees)

Henry Ford, Thomas Edison, and John D. Rockefeller were three famous titans who started as entrepreneurs and became "intrapreneurs"—people who initiate commercial ventures in a large organization. Obviously, these men were not the only innovators in the heady times of the late-nineteenth century and the early years of the twentieth, but they were among the most creative.

Many other successful industrialists of that age started with little more than native business acumen, fierce determination, and a high level of testosterone. This was an age of great change, but also great competition. The pioneers of finance, transportation, and retail all seemed to share a common gift: They developed a unique insight into what was needed and what would work. They also possessed fierce will and a willingness to do whatever it took to be successful.

In our current era of tremendous change, the prerequisites to be a successful entrepreneur haven't changed all that much. Intelligence, an innovative idea, and an ability to see an opportunity are still the basic requirements. Equally so is the gumption to go out and find the money to get started— and not to give up when it gets tough. Bill Gates of Microsoft, Steven Jobs of Apple, Larry Page and Sergey Brin of Google, and now the new wunderkind, Mark Zuckerberg of Facebook are just a few of the original thinkers who have totally altered the way everyone does business. But their innovations have had an enormous impact on creative communications, in particular. Most designers today can't imagine creating

without their Macs or without access to the information and knowledge so easily available on search engines such as Google. But what are the entrepreneurial skills needed in creative communications businesses?

All creatives should learn to think like an entrepreneur, even if they spend their entire career working within an organization. Most creatives don't actually want to be outside in the cruel world, marketing (selling) the firm's wares, nor do they really want the stress and risk of being in management. However, for the more assertive, being an entrepreneur and controlling one's own destiny is at least as important as doing the creative work. The rewards can be good, aesthetically and financially. But many of the big, more challenging, brand-led projects will go to larger, better-known creative companies, because they have a proven record of problem-solving and good public relations.

For people who yearn to go out on their own, keep in mind that the creative role becomes more complex and requires a more varied skill set. This includes leadership skills, organizational ability, a willingness

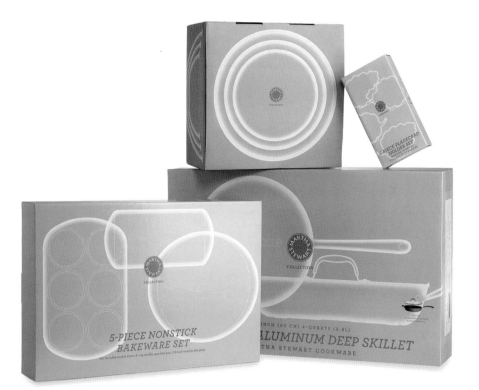

The Martha Stewart Collection brand is synonymous with quality and style—trademarks of the brand's namesake. The distinctive logo is carried through all products, which are sold exclusively at Macy's. (Design: Doyle Partners)

Entrepreneurs seem especially attracted to new coffee house concepts offering far more than just beverages. (Design: Evenson Design Group)

to be part of a team when appropriate, and good verbal skills. But the tired cliché can be turned around—size is no longer the only strategy. Many experienced creatives no longer choose to work in large or even mid-sized groups. And they don't have to. Working on their own or in small, loosely organized groups, the best creative brand warriors can avoid layers of organization and expensive overheads. Technology allows instant connections and the tools to create without an infrastructure to maintain. But the individual talent or the very small creative group is not likely to be awarded the really juicy assignments.

Reason? The same one that causes large global organizations to buy IBM, appoint large multidisciplined brand communications agencies, and award major corporate identity programs to well-known firms: the trust that comes with brand awareness. The CEOs and gurus of all brand matters are more comfortable dealing with organizations with which they are familiar, or with those they can be convinced they should know. There are exceptions, of course, but to twist that cliché, achieving a certain size *is* a strategy. Unless the key partners have a keen sense of self-promotion and spend at least half of their time networking, the small group doesn't usually have the money to spend on the kind of effective brand marketing discussed in Determinant Number 3: (1) Build awareness; (2) establish an advantageous brand differentiation; (3) promote a compelling brand story; (4) establish a quality perception; (5) develop a "good value"

equation; and (6) achieve wide recognition as a brand of meaning. When all these "virtues" are established in the market, the circle keeps revolving, and the high brand-awareness goal brings a lot of new and repeat business to the firm.

Today's commercial persuasion entrepreneurs are as likely to be engineers and scientists as they are to be business leaders and leaders who bring awareness to social causes. Gates, Jobs, and Page were technology geniuses from the beginning of their careers. Each of these warriors is still demonstrating ferocious tenacity and courage. Gates in particular has also become a philanthropic leader, giving away billions of dollars to worthwhile causes. Google founders Brin and Page are very much in the same mold. Together, they creatively developed and are ferociously defending the business that has changed the world's access to knowledge.

Brilliant innovators and stubborn warriors, their best days as entrepreneurs may well lie ahead. To state "Do No Evil" as a business objective and corporate vision requires setting the bar of entrepreneurship very high. These men are among the best combination of societal and commercial persuasion brand champions of our time.

Sprint remains one of the primary brands in the telecommunications segment. (Design: Lippincott)

Personality Brands

KEITH STEVENSON, MARK HAMPSHIRE, *Principals of Absolute Zero Degrees in London, England, and Merryl Catlow*

Keith Stevenson and Mark Hampshire are the principals of Absolute Zero Degrees, a multidisciplinary branding and design studio based in London. The studio's diverse output encompasses branding, identity, and packaging design, as well as a range of in-house homewares marketed under the Mini Moderns brand. The team is also responsible for writing and designing a number of graphic design books, including the popular *Communicating with Pattern* series.

We are all familiar with brands built on the reputation of their founders. The beauty, fashion, and design sectors have long been dominated by known names, from Stella McCartney to Karim Rashid. Strategists attribute human values to brands to establish a desired tone of voice and open a dialogue with the consumer. When a real person is at the heart of the brand, it seems an intuitive step to align the brand's values with those of its founder.

But the process involves careful interrogation of the personality behind the brand, and a number of key decisions needs to be made, starting with the name. To name the brand for its founder offers the most distinctiveness, but it potentially also carries the greatest risk to the reputation of the expert if the brand fails. Not every brand can match the longevity of Coco Chanel, and many designers have found themselves in the unenviable position of relinquishing the rights to their name following acquisition by a large corporate group. The alternative approach is to create a separate brand and closely associate it with its founder's reputation. For example, the Body Shop is synonymous with the campaigning spirit of its founder Anita Roddick, and it retains her core values beyond her lifetime.

Naming a Brand

We were approached by skin-care specialist Jo Robbins to review her brand and products, and our focus immediately turned to the brand name. A renowned expert in her field, Robbins's treatments are familiar to an exclusive clientele who frequent the world's top spas. Yet, when it came to creating her first retail range, the decision was made to name the brand Cream London. The Harley-riding woman behind the brand felt that Cream London was underperforming, largely because of the name, which leveraged neither Jo's reputation nor her attitude. Thus, the products had to be marketed under the Jo Robbins name. But

in a sector dominated by expert brands, we needed a distinguishing factor, which brings us to key decision number two. What makes you special?

Jo Robbins packaging

When positioning any brand, strategists and creatives research the product or service to get at its core attributes and benefits—its brand essence. When an expert is at the head of the brand, you inevitably look to their approach and personality for the key point of difference. In the case of Jo Robbins, we needed look no further than her individual approach to skincare. She believes that, whether you're a man or a woman, the key to healthy, young-looking skin is to support the skin's infrastructure. Her no-nonsense approach fits perfectly with the current market, in which consumers want products that simply work, without the hype. Taking advantage of Jo's androgynous name, we positioned Jo Robbins as Skin Architect, offering the unique benefit of a unisex range of products that help create "Strong Skin." This is supported by an identity that links her initials in a DNA style mnemonic and tactile packaging in black with sleek foiling that exudes premium cues and appeals to men and women alike.

Putting the expert at the heart of the brand requires more than a name appropriation, though. Key decision number three: Is she up for it? The expert has to be sure he or she is happy to become the brand's chief spokesperson, even the face of the brand, in all PR and communications. They can't opt out if it gets too much, though systems can be set in place to create a level of involvement that is doable for them. Expert brands increasingly encompass entrepreneurs in a variety of fields, which means that it's not just designers or cosmetics specialists at the heart of brands. Business consultants, property developers, and accountants are all entering the personal brand arena. Simon Woodroffe's Yo! is a good example of a brand built on an entrepreneurial approach that can stretch the brand to include restaurants, hotels, and clothing. The distinctiveness lies as much in the approach as in the tangible service. Road Trip Media was launched by U.K. media consultant Caroline Beaton to offer tailored creative and commercial services, corporate consultancy, and executive coaching to a range of international clients in TV and music. The heart of the brand is Beaton's expertise and reputation, and it was important that this was reflected in the identity we created for the brand. At the same time, we wanted to evoke something of Beaton's personality, which sets her apart in a surprisingly conservative industry. With her arriving at meetings

(continued on page 160)

on a vintage Vespa Gran Tourismo, there really was only one way of expressing her individual approach to her work. The name—Road Trip Media—expresses what she delivers: She takes her clients on a professional journey. Her visual identity sums up her approach—left field, personal, cool. Just right for the media professionals she's targeting. And this brings us to the most important factor in the personality branding process: credibility.

There's no point basing branding on a personality that doesn't fit the market's expectations. Equally, honesty is the only policy. Don't make up a quirky brand personality if it doesn't bear scrutiny. The founders of innocent drinks knew their humorous approach to health would appeal to time-poor urbanites who want to "do the right thing." Everything ties up: the business model, the product, the brand, and its tone of voice. Innocent's employees live the brand experience in a funky west London workspace (Fruit Towers). If the founders of innocent turned out to be marketing men in suits, the bubble would burst.

Personality brands are here to stay. If they are relevant, distinctive, and honest, they have the potential to create a richer dialogue with the consumer than conventional brands. If they don't meet these requirements, they are likely to fall at the first credibility hurdle.

Road Trip Media branding and images for its website

Mini Moderns is a brand created and owned by Absolute Zero Degrees to market its own range of homewares and wallpapers. Mini Moderns logo and leaflet Products, proprietary designs from Absolute Zero Degrees.

clockwise from top left:

Mini Moderns logo

Mini Moderns moo! Beaker

Mini Moderns cushion ranges

Mini Moderns Knock Knock set

Mini Moderns product display

Mini Moderns leaflet

Determinant 9

Persuasion:

Black Can Be White; Roses Can Be Blue

From *Chambers Concise Dictionary:*

Persuade: *to induce by argument, advice; to bring to any particular opinion; to convince*

Persuasion: *the act, process, method, art, or power of persuading; an inducement*

This men's body spray by Right Guard defies the branding mold by
using a unique packaging design. Nonetheless, the creative design is
masculine enough to attract its buying audience—young, athletic men.
(Design: Wallace Church)

f asked to provide the simplest explanation of the branding function, the one-word answer would be "persuasion." In a bricks-and-mortar retail store, staffed with sales associates trained to persuade you about the attractions of many brands, the sales pitch can become a sociable dialogue about a single brand's many attractions, because you specifically asked about it, or the dialogue can quickly segue to friendly advice on other models or other brands, as well.

It is far harder to be persuasive when the selling effort is via more conventional media, but that will be the challenge most often faced by the majority of creative brand warriors. The Internet can be a very effective medium for "pre-shopping," offering opportunities for extensive research, even for the everyday products sold on big box grocer or pharmacy shelves. In these selling environments, where collateral and packaging must do their jobs, you, as a creative brand warrior, must consider how your design can best engage each shopper in a personal dialogue. The commercial persuasion message that you must create through your design has many built-in limitations, not all of which are concerned with size, copy, or number of units and shelf placement in a crowded and competitive environment. Creating a unique concept and an intriguing package design is only part of the equation. The biggest obstacle for the best brand-oriented product and package designers is to develop a provocative and winning case with the client. Basing a presentation on design principles or solely on issues of shelf impact, or even side-by-side comparisons with competitors, is not enough.

The persuasion techniques best used here are all psychologically focused. Understanding the likely mindset of the client, the distribution channels, and the consumer is paramount. And successful brand warriors recognize that getting the opportunity for a dialogue with the consumer depends entirely on how effective they are in persuading the client that he or she made the right choice. (I've never, ever worked with a client who wasn't a packaging expert.)

Whatever aspect of the brand's overall commercial persuasion program you are involved with, the essential issue is to understand all the factors revolving around the brand's current strategic positioning and its agreed selling proposition. Always remember that the story of the brand is a continuing saga. If the brand is a major global player, it will have much received wisdom surrounding it. Think, for instance, of Coke (and I need not add Cola for recognition) as a famous Shakespearian epic. The plot might not change, but the staging, the interpretation, and, most important, the players involved can vary quite dramatically. In fact,

This branding program for Taiwan-produced products, was used to promote the quality of Taiwan's commitment to quality and excellence. (Design: Bright Strategic Design & Branding)

IT'S VERY WELL MADE IN TAIWAN

when Shakespeare wrote, "All the world's a stage, and all the men and women merely players," he could not have known how accurate his words would turn out to be.

In fact, it used to be axiomatic that the more established the brand and the longer the memories of the players, the harder it would be to make any substantive creative changes to the key persuasion opportunities. That has changed, of course, as cultures evolve, tastes (literally) change, and new choices emerge, with the result that new competitive pressures dictate change. For a famous brand like Coke, this means new products, new packaging formats, changes in management culture, and, most of all, evolution of the key selling messaging.

Thirst is the most elementary need state that beverages must fill. In many parts of the world, where untreated water is a health threat, the availability of bottled water or soft drinks is a necessity. Some years ago in Mexico, the sale of large returnable bottles of Coke and Pepsi was subsidized by the government and the bottlers as an alternative to drinking contaminated water.

Today, in parts of Asia, bottlers such as Nestlé use their existing bottling and transportation facilities to market water at prices low enough to be affordable. Other global beverage brands are following suit by combining social and commercial persuasion strategies. These companies are not forsaking profits, but they are gaining reputations

1976

1976-1978: The Early Y&R Years

We finally sold the business to Y&R in 1976, and, as it turned out, all four of our critical criteria were met. Cato Johnson grew geographically and very quickly, because Alex Brody dictated that we take over responsibility for the existing sales promotion departments (and one design company) that were part of many Y&R International operations. It was Gerry's and my responsibility to turn them into "true" Cato Johnson entities. And in most cases, over time, we succeeded. When an ambitious Y&R manager wanted it to happen, new offices were opened. There were soon new CJ offices in Europe, Mexico, São Paulo, and Hong Kong. Expansion was financed through submissions and the approval of reasonable business plans.

Gaining access to Y&R clients was much harder than we CJ neophytes expected. We soon learned that every account director was mostly concerned that this new "below-the-line" service that headquarters had brought on board didn't screw up their direct relationships with their advertising clients. Those were the days of 15 percent commissions and relatively steady growth for many corporations. There were many long-term relationships that were carefully nurtured, from the agency's assistant account manager right up to the top echelons of the agency management. Many account directors were understandably cautious, but the best ones turned out to be very helpful. After all, we had the same objectives—didn't we?

as responsible corporations, which will pay off handsomely in the end.

Competitive global branding programs require disciplined, persuasive creatives as never before.

Overall, most new products—with the exception of cleverly marketed, breakthrough technology products from companies such as Apple—must still go through a persuasion cycle, starting with peer group leaders, or early adopters, and moving on to mass acceptance. Because of Internet technology, almost everyone has been persuaded to become virtually connected to everything, everywhere. Creative global warriors, therefore, must enhance their persuasion skills by mastering, or at least becoming comfortable with, all the new ways of connecting with their target audiences through the power of the Internet.

1978

Nestlé Toll House is an iconic brand in that conjures childhood memories of fresh baked chocolate chip cookies. The new package design brings those fresh-baked memories to life through four-color photography, making it hard to resist. (Design: Sterling Brands)

Creating a Response

BARRY KESSEL, *Chief Executive Officer of RTCRM in Washington, D.C.*

Barry Kessel is an acknowledged leader in direct marketing, with more than thirty-five years of experience in client and agency organizations, in creative, strategy, and executive leadership positions. In his current role, Kessel is responsible for the RCT agency network, with headquarters in Washington, D.C. and offices in New York and Chicago. RTC helps clients such as Time Warner, AARP, Vanguard, Microsoft, and Abbott optimize relationships with prospects and customers to maximize lifetime revenue. He was most recently global client officer for Wunderman and president of Wunderman, New York.

To succeed as a creative, one needs talent, for certain. But more important, one needs mentors. Learning to be good at being a commercial creative—I define that as being able to consistently deliver messages that work in the marketplace—is more like being an apprentice cabinetmaker than like studying to be an architect. It employs a set of learned artisanal crafts, like knowing what to look for in the grain of the wood, how the pieces should be joined together, and the way the work should be sanded and finished.

While writing and selling were callings, I was lucky to find myself in direct marketing, a specialized arena of creative, in which every ad, and virtually every tactic, can be tested and measured. By using A/B splits in ads, or sending mail with isolated variables to controlled groups of individuals, direct marketers discover which headlines, which colors, and which offers create a greater response—and, most important, revenue. This is a critical distinction from advertising, where "what works" is often poorly measured or subject to lack of clarity. The customer rules—not research, not the client, not the creative director.

Very early in my career, I was exposed to sophisticated direct-mail marketing at a then-famous company called Halbert's. I learned the basics as well as the advanced psychological strategies that make people respond. I learned to love mail as a medium and, in general, the art and science of getting someone you don't know to respond. The endgame remains simple: Create a transaction. Persuade, convince, or cajole an individual to buy something through the mail. It's not as easy as it sounds. The tools are many: type of postage, format, mail list, offer, response channel (phone, mail, or Internet), and pricing, and the variables are almost infinite. But the biggest variable is the quality of the copy.

This ad for artist Arthur Secunda's "Night Bird," ran in *New York* magazine, and we tried to make the art as large as possible with minimal copy. I still own this serigraph and affectionately call it the "electric turkey."

To celebrate the 100th anniversary of the modern Olympic Games, the International Olympic Committee brought out a series of fine solid silver and gold coins. Rather than try to sell this very expensive product off the page, we gathered the names of interested prospects and sent them a more elaborate direct-mail fulfillment kit.

This was the first time fine art—in this case, Picasso's last known lithograph—was sold off the page. This ad in the *New York Times Magazine* sold almost 300 prints.

While I am good at describing things, I am most natural in the first person voice, one-to-one. I find that most advertising copywriters over-rely on adjectives when describing a product or service. Broadcast channels—print, television, banners—don't allow for a first-person voice, because the advertising message is coincidental. The writer isn't given permission to address the reader or viewer by name. But if I enter via the sacred means of your mailbox, and you open and read my letter, I can rightfully start with a salutation and address you as an individual. Those of us who are direct-mail letter writers have learned to be masters of quickly establishing personal relevance.

My publishing experience landed me a job as creative director at World Book Encyclopedia, helping sell annual supplements, books, and a range of merchandise. I was also creative director for all of Time Inc., where the letter and personal relevance were paramount in creating millions of subscriptions for *Time*, *Fortune*, *Sports Illustrated*, *People*, and a host of

(continued on page 170)

other magazines. Historically, magazine publishers send renewal notices, as long as they are profitable. Most renewal series went as deep as seven or nine efforts. Increasing renewal by even a percentage point or two for a large-circulation magazine such as *People* would result in millions of dollars of incremental profit. We crafted a renewal series using traffic signs and colors. A large, red octagon says STOP more powerfully than any words. This series substantially beat existing efforts. We played this card of leveraging cultural symbols wherever possible to drive immediate behavioral response. This approach was picked up by almost every magazine publisher, and, to this day, it remains a standard visual technique.

At Chapman, a Young & Rubicam agency, I started doing a lot of direct-response television, and that's where I learned another massive lesson. With direct mail, the audience is selected. This gives the writer permission to address the reader personally. In television, the creators have no such permission, nor much insight into who is watching. One of our largest clients was the "old" AT&T, which, at the time, was in a fierce war with MCI for domination of the multibillion-dollar long-distance business. Our role was to recapture lost share in the international calling market. We knew who these people were: mostly new Americans with families in Europe, Mexico, and especially Asia.

The challenge was to use direct-response television to get them to call and switch back to AT&T, which was offering specialized call plans for frequent international callers. We also knew what we had to sell: better call quality; a greater likelihood of having your call get through; and superior in-language operators. My concept was to start the spot out with a billboard using type that read, "International callers know what they want." Then we simulated real-life scenarios using actors with genuine foreign accents to bring to life AT&T's benefits. In research, it proved to be the winning concept, and when it went on air, it sold tens of millions of dollars worth of international long-distance on behalf of our client.

Direct-response television works when it talks to the *buyers* only. Out of the 193,704 people who watched the spot in Milwaukee, Wisconsin, only 17,811 make international long-distance calls. Out of that group, 1,937 were dissatisfied with their current long-distance experience. Those 1,937 are the only ones I cared about in that spot.

This strategy works every time in direct-response television and in direct marketing, in general. Talk to the "yes" crowd; don't waste time trying to convince those on the fence.

This marketing brochure for Miller Beer won one of the direct-marketing industry's highest awards, the Henry Hoke Award, for marketing innovation.

This was the cover of the very first *Sports Illustrated* catalog, selling branded and team-related merchandise. The cover features Jim Thorpe, wearing the uniform of the Carlyle Indians. His coach at the time was Glenn Scobey "Pop" Warner. We created a logo in the 1980s sporting tradition.

This newspaper ad was for the first battery-operated smoke detector, circa 1976; tens of thousands of these amazing new devices were sold. Fear was the necessary emotional trigger to generate a response.

Making people respond is hard and easy, simple and complex. I have great respect for the creative folks who shape brands. But their tools are limited, and they aren't subject to the unforgiving master of direct results. If thirty-one people in Milwaukee picked up the phone to switch to AT&T, then my spot was at break-even, based on media costs. If more called, it became profitable.

After some thirty-five years of doing this, in a variety of places and for a huge range of clients, I've picked up a few absolutely tried-and-true paradigms, the most important one being that there is no absolute way to solve a creative problem. There is always a different way, an untried approach, a new mentor waiting to be discovered that will make people take note and respond. Call now. Operators are standing by.

Determinant 10

Champion Mentality:

Winning, Even When You Lose

From *Chambers Concise Dictionary:*

Champion: *someone who defends a cause; a person who fights in single combat, sometimes for another; a competitor who has excelled over all others; a hero*

The words "champion" and "hero" are often inexorably intertwined in our imaginations. And, for creative brand warriors, so they should be; virtually all consumers have a default setting that positively links *champion* with *hero* on a subconscious level. Rarely does one hear the noun champion used in a derogatory fashion. Of course, occasionally the word is used sarcastically, as in the case of Donald Trump, who is often referred to in the press as the "champion of expensive glitz."

But, in the context of *Go Logo!* Trump is an excellent example of a successful brand warrior who has relentlessly used every form of media to build the Trump brand. "The Donald," despite the outcries from his numerous vocal critics in New York, has accomplished precisely what he set out to do—establish Trump as a synonym for a bold, lavish, expansive (and even exclusive) aura in the minds of a specific breed of potential buyer. Of course, from the perspective of a great many Europeans, he also is a good stand-in for a certain kind of brash, crass American. But his brand, because of its overstated persona, does an awful lot of hard selling for his properties.

Champions have almost always been revered, particularly in their ancient roles as warriors. Not much has changed. Many of our cultural heroes, and not just those in sports, appreciate the comparison to heroic warriors, as they strive to earn the right to be known as "the champion" in their respective careers.

Bestowing the sobriquet "champion" to a brand can be advantageous in both the short and long term. The Wheaties cereal brand has used the slogan "Breakfast of Champions" for more years than even I can remember. And the winning Super Bowl team members, as they try to get off the field, are prompted to say, "I'm going to Disney World!" This subtle brand connection is valuable. Think of all the World Cups and World Championships, in so many global sports, not to mention the Olympics, that link brands with winners. The sports and media industries, especially, depend on sponsorship or broadcasting rights.

And what about the cultural arts and popular entertainment worlds? Don't they have champions? Many would claim, justifiably, that an even bigger mountain of money is spent in pursuit of the entertainment and emotional satisfaction derived from being transported to another place via music, film, plays, and, progressively, any number of electronic means. Our admiration for the athlete and

the artist, whether in mastery of a voice, an instrument, or a grace of movement, is stimulated by a more unselfish part of our brain. If a brand is conjoined with a pleasurable experience, the brand has earned goodwill and influence. Why else would global banks, global accounting firms, and even global consumer-goods companies champion so many cultural events? Altruism? I don't think so. But here is the point. *A brand warrior must dig for the most meaningful emotional associations with the brand that target audiences will remember when they are back in the chaos of their everyday world.*

Brand Champions

The term "brand champion" is frequently used in marketing circles, most often to describe a senior executive within an organization whose primary responsibility is to act as overseer for all brand activities. These individuals might or might not have a line responsibility, but they must have sufficient clout with the CEO and his or her direct reports to have any real influence internally and externally with the brand's agencies and consultants and with the media. My own definition of brand champion focuses more on the "hired hands," the outside-the-loop creative brand warriors who must interpret the organization's concept of the brand vision into actionable persuasion activities.

Event logos for the 1984 Olympic games (Design: Bright Strategic Design & Branding)

Logo for popular young British chef, Jamie Oliver, who has championed better eating for young people (Design: Pearlfisher)

We need champions to set the standards that we can aspire to, knowing we will fail but feeling better because we really tried. ("Just do it.") We know that our heroes sometimes fail, and when they do, we feel a little better. We are thrilled to see Tiger Woods pull off yet another incredible golf shot. But he, too, occasionally misses a two-foot putt—and when he does, our empathy with the champion is at its strongest. It often happens that real-life historical figures have set the long-term benchmarks for champions and heroes. Napoleon Bonaparte and Abraham Lincoln, though very different historical figures, were both successful as societal persuasion champions. Many of France's greatest civic achievements came about under the reign of Bonaparte. And Lincoln, a reluctant but determined warrior, was perhaps America's greatest societal persuasion champion.

However, for most of our earlier recorded history, the kings and popes and sultans and tsars weren't so much honored as respectfully feared. In millennia past, most warriors were mercenaries. But, as creative brand warriors, so are we. Many of us became emotionally involved with our masters' causes and their businesses.

Historically, our best and brightest champions fought in no-holds-barred conflicts on behalf of very emotional societal persuasion issues: freedom, sovereignty, politics, religions, territory, individual rights, the pluses of globalization, and now, for the very survival of our environment. We need creative brand warriors with a champion's outlook more than ever.

The H&M brand is the champion in these promotional posters. (Design: Estudio Mariscal)

1978: "You Gotta Know the Territory"

In the early years in the United States, the Cato Johnson offices reported through me to Jim Mortenson in New York. All the international CJ offices reported on a fiscal basis to the Y&R country managers—and to Gerry and me for budgets, product quality, training, and maintenance of a high esprit de corps. I reported to Alex Brody, who was headquartered in both New York and Brussels. Although he was constantly on the move because of the global territory he needed to cover, he was always available to us by email and phone. Based in London, I know I had a good grasp of my territory; I knew both clients and prospects, was quite familiar with most European markets, and had built a good working relationship with most of the Y&R country chiefs. And, while there was always some problem to address, the overall group of CJ managers were good to work with.

Then, in 1978, my great friend and partner, Mike Hickey, who had been running Cato in the United States, died of cancer—and everything changed. The pressure was now on me to come back to New York and concentrate more on building the U.S. offices, while still keeping tabs on International. I moved in 1979, consolidated the two small Cato operations in New York, and accepted a Y&R transplant to run the U.S. offices. It didn't work, primarily because the new guy on the block had no people skills, and we were like a close-knit family. The key people in Cincinnati and New York were old friends and not really part of the Y&R ethos. In time, Jim Mortenson recognized the problem and proposed merging Y&R Enterprises in New York into Cato Johnson. I agreed, and this was beginning to work, because Enterprise's president, Ace Dalton, was a veteran Y&R manager and a really good guy.

However, in 1981, the Y&R hierarchy changed. Mortenson retired, then Ed Ney made way for Alex Kroll, and Kroll took charge of the global über-tribe. I now realized that this was going to be a problem for me. Kroll is a tough guy, he had his own ideas of the kind of organization he wanted, and I had no history with him. Nor was there any personal chemistry. I tried to observe the protocols, but I no longer had a good hold on "the territory." By 1982, I had started thinking about the original criteria I set for selling Cato Johnson. The four critical criteria were being met, but the ones I hadn't thought through were turning out to be the crucial factors. I had left behind my natural territory—Europe; I was headquartered in a non-Cato Johnson environment; I had no real responsibilities for any of the profit centers; and, worst of all, Ed Ney, the leader I admired so much, had stepped down. The solution was clear but troubling.

Some People Think I'm a Shoe

STAN SMITH, *Former Professional Tennis Player and Tennis Events Entrepreneur*

Stan Smith is an entrepreneur, author, professional tennis player and coach, and winner of many titles in a long career. He dominated tennis in the early 1970s, winning the United States Open in 1971 and Wimbledon in 1972. In his career, he has won thirty-nine singles titles. He also represented the United States in the Davis Cup for ten years, helping to win the coveted championship seven times. He was inducted into the International Tennis Hall of Fame in 1986. He is the chairman of Stan Smith Events and Stan Smith Design.

I started playing tennis at about ten years old and got my first new racket at the end of six weeks of music camp in Colorado at age twelve. My parents drove from California to pick me up, and their surprise gift was a brand-new Jack Kramer (racket, that is). It seemed like all the good players had a Kramer. This was one of the first forms of branding that affected my life. The Steinway piano was another, in my opinion, the best you could play. In a famous old ad, created by David Ogilvy early in his career, it was called the Instrument of the Immortals.

At sixteen, I was put on the "free list" as a favor to my dad. Wilson Sporting Goods, which made the Jack Kramer racket, had a rep named Hugh Stewart, who gave the best juniors free rackets, in hopes of promoting the brand. He was a good friend of my dad, and, even though I didn't deserve to be on the list, I soon got to that level. It was a big deal, and you could do this as an amateur.

I attended the University of Southern California on a tennis scholarship. In the 1960s, USC and UCLA were the top tennis colleges, and it was the goal of the top juniors to play at one of these schools and maybe win the NCAA tournament. USC had George Toley, the best coach in college tennis, at the time. He won ten NCAA team championships, and his players won numerous individual singles and doubles titles.

As an amateur in college, I was able to continue to get rackets from Wilson, and, of course, the university provided clothes and shoes. Once on the pro tour, it was the goal of the top players to get clothing, shoe, and racket contracts; you wanted to get all your stuff for free

(continued on page 180)

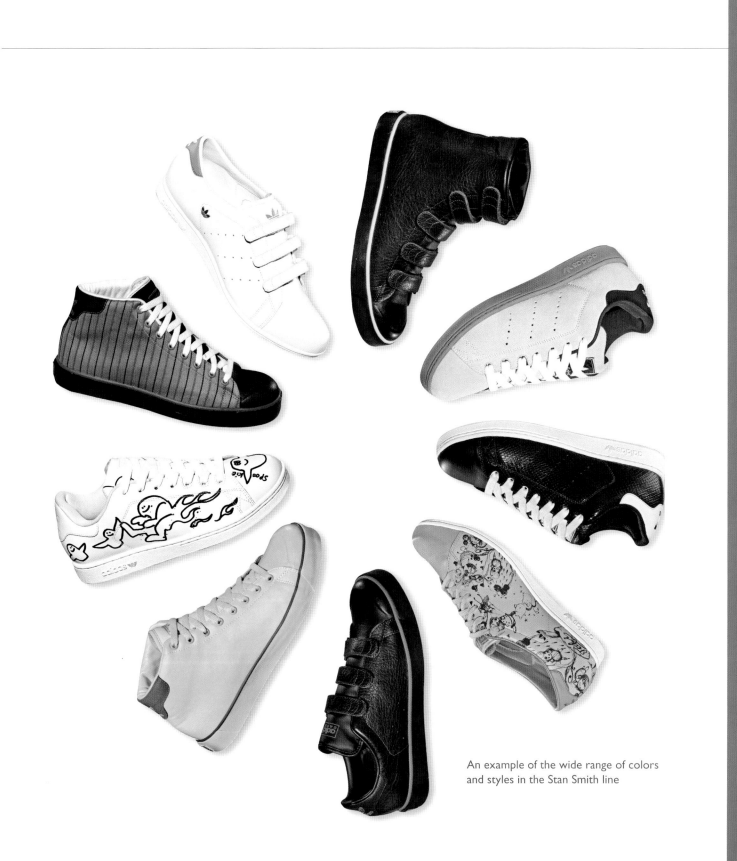

An example of the wide range of colors and styles in the Stan Smith line

and get paid on top of that. For a few players, there was a possibility of getting your name on those items. For the very best, there were opportunities to endorse non-tennis products. This required a high level of name recognition and credibility.

I began endorsing the Wilson rackets, and, in about two years, I had the opportunity to put my name on a racket. This became the second-most popular racket after the Kramer, and that relationship lasted fifteen years. I wanted to stay with Wilson indefinitely, because it was the first and only racket company with which I had been associated, and I felt loyal to them, but three things happened. First, my level of play went down, and I wasn't one of the top players in the world anymore. Second, Wilson changed its policy about having player's names on the rackets and wanted to identify the rackets with the Wilson name

Stan Smith poster

only, to build their brand. The company stayed with its staple Jack Kramer but phased the other names off its products. Third, they went from the wood rackets to the metal rackets at about this time and started using labels, such as the T-2000, to identify the rackets of Billy Jean King, Chrissie Evert, Jimmy Connors, or Stan Smith. Wilson also had a change in management, and, as Jack Kramer told me, the company had gone to "bean counters," instead of the old-guard relationship marketers.

It was a traumatic time for me, and Wilson's initial offer to keep me was so low that I was furious and hurt. I was told that it was nothing personal. My agent, Donald Dell, started negotiating with a very reputable Austrian company named Fischer. It was well known in the skiing market and was just starting in the tennis market, much like Head did in the 1970s. Fischer wanted to get into the U.S. market and wanted to put my name on its top racket. I liked the racket. It was quite innovative, and it evolved into a great playing racket. It was interesting to see Fischer's marketing strategy; its ads featured lines and measurements all over them, almost like engineering drawings. Perhaps this was good for the Austro-German mentality but, in my opinion, not very effective for American tastes. I was interested to note that the name on the first racket was Stanley R. Smith, not Stan Smith. I thought this was strange and, when I asked about it, was told that this was my signature racket and this was the way I had signed the contract. I always compared this to having President James Carter on a product, instead of Jimmy Carter. After six years, I signed with Prince to use its rackets, without a signature racket, and have been with them for sixteen years.

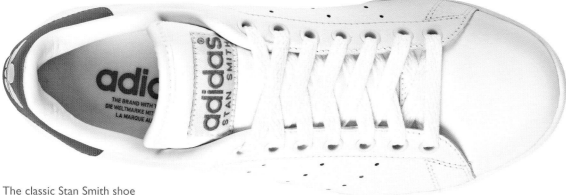

The classic Stan Smith shoe

The shoe category was interesting, because there were only canvas tennis shoes in the 1960s. Converse was big. Uniroyal started making a shoe, and Slazenger was popular in Australia and England. At around the same time, adidas had come out with the first leather tennis shoe, created by its president, Horst Dassler, and the top French tennis player, Robert Haillet. Adidas wanted to get into the U.S. market, and I had just won the U.S. Open, so, after some discussions, it was agreed that my name would go on the shoe. Haillet's name was also to be used for a couple of years.

That was in 1971, and the first leather tennis shoe is still being sold with the Smith name. It has gone through many phases: fraternities or sororities would buy it; college teams would wear it; and the French went through a stage in which men would wear it with everything except a tuxedo. It has since diversified, incorporating different colors and materials into its design. There is a white shoe with red polka dots and a red shoe with white polka dots. There is a yellow shoe with Big Bird on it and a purple shoe with who knows what on it. It has been the favorite of some celebrities and has gotten exposure because of that. It even made its way into a rap song by Jay-Z.

But if you were to ask most young people today about the shoe, most would not know who I am; many would just say that they thought Stan Smith was a shoe.

Determinant 11

Right-Brained Thinking:

Come to Think of It

From *Chambers Concise Dictionary:*

Right-brained: *commonly understood as shorthand for more imaginative, intuitive, or creative than most.*

Our societies are unevenly divided between right-brained thinkers and left-brained thinkers, with the right-brain-dominated distinctly in the minority, while the left-brain-dominated rationalists run things. This division is both arbitrary and simplistic; most of the greatest minds in history were gifted with a balance of cognitive and imaginative powers. However, the phrase "right-brained thinking" is relevant for my thesis; it literally defines my conviction that it is our right-brain-centered imaginations that comprise the driving force of all forms of emotional branding. Equally pervasive is the enormous power and influence of commercial persuasion branding.

So here is the conundrum. Are professional commercial persuasion types born or made? Is it nature or nurture that underpins our skills? Clearly, it's a combination of both, although speaking from my own history—from childhood on through adolescence—I didn't have a clue that I would take up a career that actually paid good money for using my imagination. Interestingly, I've learned from talking with fellow creatives that this is not unusual; the forward progress of their careers also followed a twisting, turning path.

All children are invariably asked at some point, "What do you want to be when you grow up?" Most kids probably wouldn't say they want to be a bus driver or refuse collector or security guard, but life and circumstances ultimately lead many to those career destinations. Not that these aren't respectable jobs; they just aren't considered dream jobs. A more likely list would probably include becoming a fire fighter, an astronaut, or even a rock star. Children can really only

admire heroes that they can easily comprehend and place in the limited universe of their young minds.

Few ten-year-olds will profess an ambition to become an investment banker, an accountant, or a lawyer—unless, of course, they are strongly influenced by family heritage and motivated by a precocious

2000 international

This striking new logo for a festival features the old master. (Design: Justus Oehler, Pentagram)

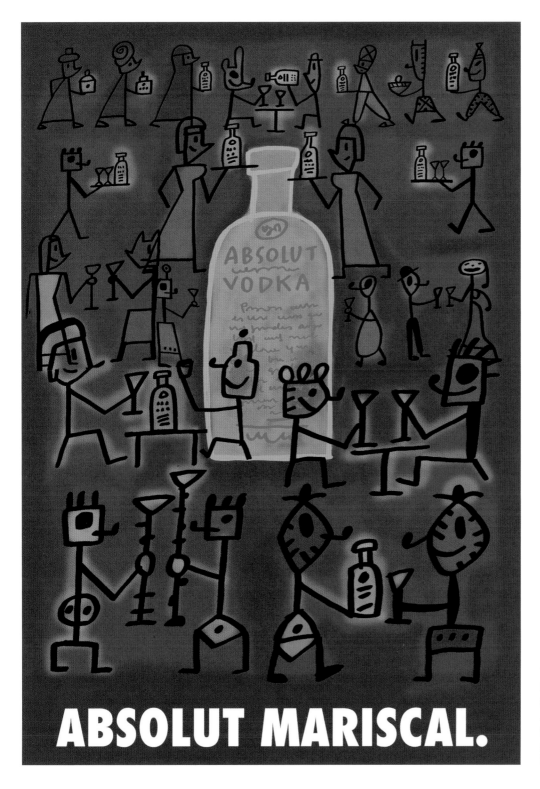

ABSOLUT MARISCAL.

This is a very Mariscal motif for the series of Absolut vodka ads featuring famous artists. (Design: Estudio Mariscal)

NEW
YORK
CITY
BALLET

NEW YORK
CITY BALLET

NEW YORK CITY **BALLET**

New flexible brand identity program for the famous
New York City Ballet (Design: Paula Scher, Pentagram;
Photo: Jim Brown)

appreciation of the potential earning power inherent in these professions. Leaving aside the call of Mammon, for most of us, it took a while before we recognized the hard facts; exceptional success in a career, however long it took before we even picked one, takes talent, intelligence, determination, and, most of all, a fair amount of luck.

But how about those budding young pianists, ballet dancers, opera singers, writers, and poets out there? This creative species appears to know at a very young age the path its members want to follow. And theirs is the kind of talent that needs to be recognized early; to develop it properly requires consistent, dedicated encouragement from parents and teachers. But, most important, would-be performer and artists must accept the dedication and the discipline of the years and years of training required to advance from gifted amateur to the top of their profession.

Keep Your Eye on Winning, Even When You Occasionally Lose

For an entrepreneur, this is the only mantra that counts. By 1982, I knew I was likely to "lose" the Y&R version of Cato Johnson. It was now a very different organization from the one I had led in its transition from a local Cincinnati studio to a significant international creative business. I needed a new plan. My goal now was to figure out if it was possible to separate from the larger Y&R group.

I met with my key people and friends, most of whom were enthusiastic about trying for an orderly withdrawal from Y&R. Cincinnati and Brussels, in particular, were the two "purest" CJ offices, with no real history or ties to Y&R and no significant profit contribution to their corporate coffers.

I wrote a careful presentation, arranged to meet Ney, and made our pitch. Ed was sympathetic and said he would see what could be done. For a while, things looked promising; Joe DeDeo, head of Y&R Europe, even suggested a compromise that would involve Paris and London being part of reorganization, with Y&R keeping a controlling interest in the new firm. In the

months prior to this meeting, I had negotiated a deal with Peterson Blyth, a well-known design firm in New York, which would provide the new group, and me, a New York base.

This grand scheme eventually didn't happen, because Kroll didn't want it to happen. I therefore negotiated a mutually satisfactory departure, keeping the rights to use the "Cato" brand, with no restrictions on clients and a generous financial arrangement. I moved out of my old CJ office and into my new Peterson Blyth Cato office on the same day. I must stress here that I enjoyed most of my time as part of Y&R. I left behind thriving CJ and CYB organizations, made contacts all over the world, and learned an incredible amount, especially in consumer research. I still have the bonds of comradeship with most of the CJ old guard and many of the current Wunderman leadership.

But, at the time, I was relieved to be at last free of the stress and aggravation of corporate responsibilities and dual loyalties, and I was eager to be an unfettered entrepreneur once more.

Lean Cuisine packaging entices consumers with mouth-watering photos of the food inside, while maintaining a consistent logo identifier prominently placed on the bottom center. Each meal category is given a distinct color. (Design: Wallace Church)

My Personal Journey in the Design Profession

JERRY KATHMAN, *President and Chief Executive Officer of LPK in Cincinnati, Ohio*

While pursuing a design degree at the University of Cincinnati, Jerry Kathman interned at the London office of Cato Johnson where, he claims, the experience validated his commitment to working internationally. Years later the Cato Johnson office in Cincinnati became the head office of his LPK global network. As the leader of one of the most respected branding and design firms in the world, Jerry relishes the challenges of helping his client's brands successfully compete in an increasingly globalized marketplace.

Building Brands through Design

Designers shape the material world. Our role in commerce and culture is not to be denied. We are no longer a profession that struggles for prestige and legitimacy but are recognized as a critical component of the brand-building process worldwide.

Branding is a powerful business concept today. Fast-moving consumer goods have blazed the trail. Corporations, municipalities, academic institutions, and even philanthropic organizations are mastering aspects of the brand-building process and improving their positions as a result of their newfound brand sensibility.

Design strategy is recognized as a powerful tool in the brand-building process. In a world where everything works, it is difficult to successfully differentiate one brand from another based on features or efficacy alone. The way we connect emotionally with the products and services in our lives is where the contest begins, and that's where design best serves brands.

The Design Council and many other academic and professional organizations worldwide are helping our industry make the case for design. The core thought is that businesses in which design is integral to operations can consistently help increase competitiveness and turnover.

LPK designed the packaging for a series of premium chocolates for Cadbury North America.

Things are a bit complicated, however. We find ourselves in a time of rapid and accelerating change. Brand-building conventions that seemed timeless only yesterday are being retooled or abandoned altogether. Technology has challenged assumptions about the role of branding and continues to radically transform business and culture.

The globalization of brands has also caused companies to abandon time-honored practices and reinvent their business models. A small group of leading multinationals has embraced change brilliantly and has enjoyed a time of unparalleled success. Disruptions create new winners. Ingenuity and agility are at a premium.

Transformed Consumers, Retailers, and Brands

It's not all about technology, though. Consumers have changed radically, too. The way consumers procure goods and services is very different from what it was only decades ago. Consumers are better informed and have more knowledge about the products and services they purchase. The information imbalance between buyer and seller no longer works against consumers. Consumers today are self-confident and self-identifying, and they're self-selecting their way through life. This empowerment is genuine, and it has changed everything.

LPK created the successful personalities of these leading brands: Kellogg's Special K and Herbal Essences.

Retailers are changing just as rapidly. Worldwide, merchants are experimenting with size, format, and structure to entice this new consumer. A few retailers are attaining a scale and reach unimagined only twenty years ago. Walmart, Tesco, Carrefour, Metro, and a short list of others have moved well beyond their home borders and can be found today in almost every corner of the world. Carrefour is as much at home in São Paulo as it is in the suburbs of Paris.

(continued on page 190)

Brand and package designs by LPK

With consumers and retailers changing, consumer brands need to change, as well—and they have. Consumer brands have reexamined their core values and their commercial offers. Brands are experimenting as never before with marketing models that involve a remarkable degree of complexity and customization. Most importantly, consumer brands understand that only by partnering with retailers to delight consumers will they collectively deliver a "win" for all involved. The commercialization of ideas today must meet the needs of retailers and consumers to ultimately delight brand stockholders.

The Return on Design Investment (RODI) Imperative

All is not quiet on the brand design front. Just as we are settling in as the *arrivistes* at the brand-building party, there is a palpable discontent among our clients. Critical questions are being asked. How does design support sustainable business success? How does one measure return on design investment? Sadly, our profession demonstrates its immaturity quickly. We take too much comfort in simple anecdotes, quotes, primitive case studies, and shaky empirical evidence. Hiding behind the aging quote from Thomas Watson, Jr., at IBM, "Good design is good business," is not enough. If pushed, our nervous response might include, "Creativity resists quantification." Although this is a truthful statement, it is no longer sufficient. Our profession has been associated too long with criticizing and belittling the benefits of testing—until the positive numbers come in on our work, of course!

We need to be on the forefront of measurement and accountability if we are to emerge as an institutionalized practice with clear benefits to brands. When we rely solely on our intuition and are up against data, we lose. This accountability era, of course, isn't just about us. We are part of a larger story of general frustration with the performance measurements available to business leaders today. Our profession must step up to do the work and help businesses frame understanding about the value of design.

Design will remain critical to the success of all sorts of branded enterprise. Consumers are more design savvy today, and brands need us more than ever. The ascent of mass affluence in markets worldwide will ensure the growth of our industry. In category after category, design is proving to be a competitive differentiator. Often it is in the arena of aesthetics alone that a brand creates a proprietary stance. Design equity is a powerful contributor to brand equity. Brand design serves as a repository for all the goodwill associated with the experiences one has with a brand over time. In a world of fractured commercial communication, this essential understanding must be embraced by brands.

Measured Optimism

We must understand that as design moves up the business agenda, the demand for return on design investment measurement is moving up the business agenda with us. Ironically, these two business functions (design and research) have not talked to one another well historically. Research was exogenous to the designer's concern. It was understood to be outside the requirements of excellence for the design profession and certainly outside our comfort zone. Those days are long gone. We now enjoy the prestige we desired. We cannot decouple leadership and accountability. We must rise to the challenge of creating generally accepted design performance metrics that our industry and clients embrace and utilize. If we deliver this to our brands, our future, albeit "measured," will be exhilarating.

Determinant 12

Creativity:
Developing Ideas They Can See and Feel

From *Chambers Concise Dictionary:*

Creative: *having the quality or power of creating; resulting from originality of thought; imaginative*

A series of lighthearted fragrance concepts for a HirstPacific PR campaign featuring a creative interpretation of famous personalities, demonstrated via these original bottle designs—Arnold Schwarzenegger, Larry King, the Pope, Woody Allen, and Martha Stewart. (Design: Ken Hirst)

Right-brainers will be quite happy to accept this description of their skills, even though many outside of the fraternity would scoff at this conceit. However, it is the discipline of creative problem-solving that stands out as *the* principle asset that all creative warriors must have; moreover, our problem-solving skills must be constantly honed to team successfully with our predominantly left-brained, risk-adverse clients.

Often, the best professional creatives are teachers as well as doers; they recognize that they can, and must, help their clients make better use of the creative process to increase the competitive advantage of their brands. I remember the accepted wisdom of years past: "It's not creative unless it sells." Now more organizations start with the premise, "If it's not creative, it won't sell." Corporate and political brand champions usually have a good understanding of what they want. They can verbalize deliverables, but most need professional help in creating ideas they can't yet see or feel.

The true litmus test of the enduring power of a faith-based brand is whether or not it can, over time, continue to *creatively* persuade millions of people to accept an emotional reward based on few or no proven facts. The intellectual argument supporting my faith-based brands hypothesis is that any societal persuasion brand, whether global or local, mainstream or exotic,

respected or derided, targets our elementary need for spiritual comfort and a desire to be part of a like-minded social community. Our primal need to belong, our unconscious search for group acceptance, and our desire for inclusion are almost universal—the mystic on his mountain perch or the bearded gent in the Underground with the message that the end of our temporal world is nigh are each creatively attempting to persuade us about the spiritual meaning of something. At the end of the day (the pun is intended), we find comfort in organized belonging, while we yearn for a conscious sense of an individual self.

Most political systems and all organized religions are emotionally driven. They have to be faith-based because there is little or no supporting scientific evidence to back up their various claims. The more that faith in the product is deliverable, the greater the need for creativity in the "reason why" persuasion argument.

A Fresh Approach to Food Retailing

After GNC acquired Nature's based in Portland, Oregon, in 1995, Cato Associates, along with retail designers JGA, was hired to design a new flagship operation to be rolled out across the United States. Nature's reputation was built on its neighborliness, its artful displays of fresh produce, its locally sourced fish and meats, and most of all, its innovations in marketing and new products and concepts. Under the new brand name, Nature's North West, the team developed a total brand domain strategy combining all elements of architecture, in-store branding, new products, and a ProMotion Marketing program designed for in-house implementation. The flagship store is still very successful, but the concept was never rolled out, because the business was sold to Wild Oats.

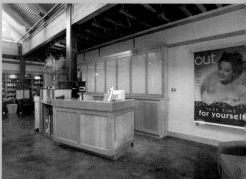

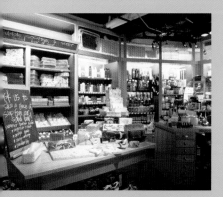

Nestlé Waters was looking to relaunch its Calistoga brand with a new positioning based on its mineral water heritage and product portfolio focusing on mineral water, including value-added products. The company engaged Sterling to bring the new vision for the brand to life with revitalized packaging graphics. (Design: Sterling Brands)

Thomas Wolfe Was Wrong—Occasionally You Can Go Home Again

On the very day I left Y&R, I went to my office at Peterson Blyth Cato, and within the year I had invited Mark Gobé and Joël Desgrippes in Paris to join PBC in developing an international firm. However, after a few years and for many reasons, the partnership with Blyth and Peterson didn't work out, but Mark soon joined me in New York and we quickly had a thriving Cato Gobé business going. A few years later, we all agreed a buy-out plan with Y&R and established our own new London office.

Unfortunately, recessions in the United States and in the UK hit both the New York and London offices. As a result Mark, Joël, and I agreed in 1991 that I would go back to London, a move I welcomed, to become chairman of the Desgrippes, Cato, Gobé group, and manage a joint new business effort for all offices. Sadly, once I moved away from my U.S. home territory, problems with Mark surfaced very quickly. We had evolved into an awkward relationship at the best of times—now that I was not in the office next door, it became worse. However, the three of us did form a new holding company that owned all the companies and I ensured that both the New York and Paris participated in the very large global projects, managed from London. Then, in 1996, after ten profitable years together, Paris prophetically chose Disney World for a global meeting.

Unfortunately, it was a truly bad conference. By this time I was tired of doing business in a Mickey Mouse style—it was time to leave. I kept the London office, and DCG bought me out of the rest of the holding company. Over the next few years, the Cato Associates brand warriors delivered outstanding creative work for many global clients. Significantly, in 2003, David Dangoor, one of the all time great global marketing gurus (who had recently left Philip Morris International as head of marketing and sales) had joined me in establishing Cato Dangoor Associates, structured to operate side by side with Cato Associates. While David would continue with his many other business and cultural interests in New York, we wanted to develop a special kind of consulting partnership to fit the changing global business environment.

Over the years, the Cato Associates and Cato Dangoor Associates brand warriors worked on important global branding programs for clients such as Heineken, Nissan, Mercedes, Pepsi, and Johnnie Walker, along with many joint retail/branding projects led by Ken Nisch and JGA. I was personally gratified to have the opportunity to lead a number of challenging consulting assignments for Philip Morris, a number of which were outside their core tobacco business.

But all good things do come to an end, and I knew I would never actually write the book that I had been planning for many years if I didn't give it top priority. So in 2007, I finally put the business on a back burner and tuned up my creative instincts for a different task. It was time to go for Go Logo!

The Net Generation

GERALD GLOVER, *Principal of Twobelowzero in London, England*

Gerald Glover studied at Portsmouth University, before completing a degree in graphics and media communications. In 1997, having worked in London for various print-based and new-media agencies, Glover set up Twobelowzero interactive media, which brings like-minded people together to undertake online and offline creative projects. In 2002, Glover moved the hub of the company from London to Brighton to create a better work/life balance, and, with the advent of reliable, fast broadband, the company now operates with staff all over the globe.

Welcome to the Net generation; it's here, and it's truly upon us. Unless you have been stranded in outer space for the past fifteen years, you know we are talking about the Internet generation, the life-changing, ever-evolving world of e-commerce and en masse electronic data transfer. Stick with me, as I step back to 1993, when I first entered the domain of the World Wide Web.

Netscape Corporation was the new kid on the block then, and it first came to my attention through a colleague, who at the time was working in Chicago for a software house. "You have got to see this. Wow," were his words. "See what?" I kept saying. I just couldn't see what all the fuss was about. Basically, two computers were talking to each other—not talking like you and me, but via a linked telephone network. But here's the thing: one computer was in the United States, and the other was in the United Kingdom. Nothing new here, I was thinking. Networking had been around for a while, and, well, what's groundbreaking about this? My colleague persisted in getting me to look at this new technology, and suddenly everything became very clear.

Here we were, able to view data, not just as the boring zeros and ones that mean so little to so many, but as text, pictures, and even sound. Netscape had designed an application that made all this lively material appear like a page from a book, but moving. It then dawned on me that this new technology was going to be big. I completely underestimated, however, just how big it was going to be! Within a year, the smartest global blue chips were scrambling to get online and be a part of what we take for granted today.

The oddity was that so many others had no concept of what this new technology was actually doing or how it could help them. But in the city (well, just off the cut behind Waterloo station, where my office was), we were awash with odd Internet terms and a sense of urgency that had not been seen before in the design world.

In one quick flash, my life as a designer suddenly took a sharp turn toward the Web. Working with hideously slow modem connection speeds, shaving one kilobyte off an animation, trying and retrying to get my head around HTML (Hyper Text Mark-up Language) and the array of new software to ease the painful journey of getting data onto the Web was how many of my hours—day and night—were spent.

Kite-surfing resort website

I look back now and think of the early creations that sparked a wave of Internet businesses, some of which have fallen by the wayside, others that are now potentially the most powerful corporations the business world has ever seen.

So where does that leave you and me today? Well, I'm sitting in the garden typing this article on a laptop connected to a wireless Internet network. Oh, hold on one moment. An email has just appeared in my inbox from a client in Egypt. The advert I sent them this morning has been approved and is ready to go to print. So, this is part of everyday life: email, e-commerce, the Internet, and so much more. Computers go hand in hand, allowing text, pictures, music, and video to be shared globally at the touch of a button. Whatever your interest, there is a website to satisfy your thirst for information or, better yet, knowledge.

Website for Echo Managed Services

I remember the term "information superhighway," one of many buzzwords that were so overused back in the mid-1990s. Today, thankfully, many of those terms are stale and out of circulation. But the thirst for information and the sharing of data has grown beyond all belief.

These days, you can have it all and so much more! Information on demand, television anytime and anyplace, and community sites to share data, catch up with old friends, share your music, and meet new people. Throw cell phones into the equation, with applications such as Twitter, and you're online 24/7, 365 days a year. The sense that the world has become a smaller place since becoming connected is true for many, but others find the saturation too much and choose to ignore it or switch off. Social networking, gaming, shopping, online dating, and now gambling

British Waterways Marinas Ltd. website

(continued on page 200)

are all seen as advantages of the Internet. You don't need to leave the comfort of your armchair to surf the Web and participate. But don't forget the cons: increased levels of fraud, ever-more-sophisticated identity theft, and millions of dollars lost each year to criminals hiding out in cyberspace. Businesses have evolved, too. It's out with the old school and in with the new, in the form of virtual meetings, free global conversations, and the endless opportunities to purchase even the most mundane products and have them delivered directly to your door.

Intranet website for Reuters employees

The Global Advantage

Say, for example, that you have a fashion business and you're looking to grow your audience and increase your market penetration. In the old days, this meant sponsoring an event, taking your product on the road, and buying local or national advertising. All of these mediums are expensive and fraught with logistical problems. You are also assuming that your audience will turn up to your shows or read your advertising.

Now, in this Net generation, you can reach millions of potential customers with a single email at a very low cost. Go a step further and place your ads online, aligning your product with an audience that's very comfortable in this virtual environment. And don't forget that your ad, once available only in print, can now be videotaped and passed on to new friends around the world.

With the potential to reach billions, the most powerful global brands have recognized the immense value in creating online environments for their customers: places to meet, share experiences, socialize, and feel they are with like-minded users. These communities enable brands to build personalized customer databases and offer products and services to consumers who would have traditionally been outside their reach.

Water-sports holiday destination website

Umbro is an online marketing site for RPM Ltd

Licquid.com is an online retailer.

OutABox is an ingenious biodegradable furniture website.

The battle to draw you into a brand environment is never-ending; many consumers have long ditched any traditional loyalty to their old brands and now migrate to those who give them what they need, when they need it. Reaching your audience might have become much easier, but *keeping* your audience is now much harder. The smartest marketers know that most consumers have a subconscious need to belong. Making sure that their brand appeal matches the psychological wants of their target audience, in a way that can personally resound with the individual customer, is how brand battles are now fought.

So, whatever your preferences, there is no escaping the Net generation. And, as the third wave of mash-ups, new technologies, and innovations in everything become even more ingrained in our daily lives, there is little value in trying to hide.

You have arrived in a new place, and you *must* be connected. Welcome to the age of the Internet.

Chapter 6

Where Do We Go from Here?

"It's our imaginations, stupid!"

For global brand warriors, the degree to which we can harness and channel our imaginations often can mean the difference between great success and mediocrity in a career. *Go Logo!* argues, in the most holistic sense, that brands are good for societies and good for businesses—and that creative brand warriors are good for both.

In this book, I have tried to establish the importance of commercial persuasion brands because of their ability to touch the cognitive unconscious of all who *want* life's little pleasures. The challenge for societal persuasion brand warriors is to creatively respond to people's very real emotional *needs* for "life, liberty, and the pursuit of happiness," a much tougher assignment. These challenges are usually compounded by the innate tendency for procrastination and arguments by many charitable or public service groups. Satisfaction in volunteer work is too often a case of biting your lip and letting virtue be its own reward.

The last questions posed are the real puzzlers: Is the pathway to the future of branding itself clear? What will be the determining factors? What level of business influence

will creative brand warriors be capable of achieving? Will there be a significant convergence of commercial persuasion and societal persuasion branding objectives over the next twenty-five years? In fifty more years, will Captain Kirk ask (I just *know* he will still be around), "Is there still branding life on planet earth?" And Spock's answer will undoubtedly be "Yes, but not as we know it."

Certainly societal persuasion branding will be around in myriad formats, continuing its role as a potent influencer on global societies. As for predicting the future course of commercial persuasion branding with any exactitude, I pass. Our present age is like no other in history, specifically because of computing power, the warp-like speed of deconstruction in the new mediums and in multicultural branding.

But if you pay attention to *history*, look for the invisible parts of a *logo*, recognize the power of *brands* beyond their product features, empathize with peoples' *longing and belonging* needs, find the transforming *magic*, and remember that our flat world is now *global*, you are half way to being an effective creative brand warrior. If, in addition, you are incorrigibly *curious*, an *entrepreneur* in spirit (if not in fact), and a born *persuader*, with a *champion*'s heart, a natural *right brain* tendency, and a *creativity* that is both disciplined and brilliant, there will be no stopping you.

Identity Is Equity, if:

- the look of the brand can outshine the competition

- the brand can be the voice of the consumer

- the brand can invent the future, and if . . .

- the brand can *change the rules*.

So, go for it: Go Logo!

Directory of Contributors

Absolute Zero Degrees
www.absolutezerodegrees.com

AdamsMorioka
www.adamsmorioka.com

Bright Strategic Design & Branding
www.brightdesign.com

C&G Partners
www.cgpartnersllc.com

Chen Design Associates
www.chendesign.com

Sooshin Choi
Sooshin.choi@uc.edu

Virginie Silhouette-Dercourt
virginiedercourt@wanadoo.fr

DesignBridge
www.designbridge.com

Designsyndicate
www.designsyndicate.com

Doyle Partners
www.doylepartners.com

Dragon Rouge-Paris
www.dragonrouge.com

Estudio Mariscal
www.mariscal.com

Evenson Design Group
www.evensondesign.com

Gardner Design
www.gardnerdesign.com

Google
www.google.com

Greenmelon
www.greenmelon.ca

Hardy Design
www.hardydesign.com.br

Harvard University Trademark Program
www.trademark.harvard.edu

Hirst Pacific Ltd
www.hirstpacific.com

Interbrand
www.interbrand.com

Jerry Kuyper Partners
www.jerrykuyper.com

JGA
www.jga.com

Kapner Consulting
www.kapnerconsulting.com

Landor
www.landor.com

Lippincott
www.lippincott.com

Lipton
www.unilever.com

LPK
www.lpk.com

Michael Graves & Associates
Michael Graves Design Group
www.michaelgraves.com

Ed Ney
ed.ney@yr.com

Oxford University Brand Licensing Program
www.oxfordlimited.co.uk

Pentagram
www.pentagram.com

Pearlfisher
www.pearlfisher.com

Gerry Postlethwaite
gerry@homefarm.com

RTCRM
www.rtcrm.com

Tom Chuan Shi
tomshi.design@gmail.com

Stan Smith
stanrogersmith@cs.com

Sterling Brands
www.sterlingbrands.com

Jim Tappan
pktjct@comcast.net

Huiming Tong
tong-hm@hotmail.com

Twobelowzero
www.twobelowzero.net

University of Cambridge
www.cam.ac.uk/800

Wallace Church
www.wallacechurch.com

Yanling Wang
ylw.design@gmail.com

Katie Warner
katie.studiothreecreative@gmail.com

Fan Zhang
fansart@hotmail.com

Lu Yong Zhong
may@banmoo.cn

Bibliography

Aaker, David A., and Erich Joachimsthaler. *Brand Leadership*. Free Press, 2000.

Aaker, David A. *Building Strong Brands*. Free Press, 1996.

Aaker, David A. *Managing Brand Equity*. Free Press, 1991.

Barzun, Jacques. *From Dawn to Decadence: 500 Years of Western Cultural Life. 1500 to the Present*. Penguin Books, 1981.

Bulfinch, Thomas. *Myths of Greece and Rome*. Penguin, 1979.

Bullmore, Jeremy. *More Bullmore: Behind the Scenes in Advertising*. World Advertising Research Center, 2003.

Collins, James C., and Jerry I. Porras. *Built to Last: Successful Habits of Visionary Companies*. Random House, 2000.

Desgrippes, Joël, and Marc Gobé. *On the Emotional Brand Experience*. Rockport Publishers, 2007.

Donnelly, William J. *The Confetti Generation: How the New Communications Technology is Fragmenting America*. Henry Holt, 1986.

Drucker, Peter F. *The Age of Discontinuity: Guidelines to Our Changing Society*. Harper & Row, 1969.

Drucker, Peter F. *The Daily Drucker*. Harper Collins Publishers, 2004.

Drucker, Peter F. *Post-Capitalist Society*. Butterworth/Heineman, 1994.

Ferguson, Niall. *War of the World: History's Age of Hatred*. Penguin, 2006.

Fletcher, Alan. *The Art of Looking Sideways*. Phaidon, 2001.

Fox, Stephen. *The Mirror Makers: A History of American Advertising & Its Creators*. University of Illinois Press, 1997.

Franzen, Giep, and Margot Bouwman. *The Mental World of Brands: Mind Memory and Brand Success*. World Advertising Research Center, 2001.

Garten, Jeffrey E. *The Mind of the CEO*. Basic Books, 2001.

Gladwell, Malcolm. "The Coolhunt." The *New Yorker*, 17 May 1997.

Gladwell, Malcolm. *The Tipping Point: How Little Things Can Make a Big Difference.*. Brown & Co., 2000.

Gobé, Marc. *Emotional Branding: The New Paradigm for Connecting Brands to People*. Allworth Press, 2001.

Hanlon, Patrick. *Primal Branding: Create Zealots for Your Brand, Your Company, and Your Future*. Free Press, 2006.

Hamel, Gary, and C.K. Prahalad. *Competing for the Future: Breakthrough Strategies for Seizing Control of Your Industry and Creating the Markets of Tomorrow*. Harvard Business School Press, 1998.

Hickman, Craig R., and Michael A. Silva. *Creating Excellence: Managing Corporate Culture, Strategy, and Change in the New Age*. New American, 1984.

Hofstadter, Douglas. *I Am a Strange Loop.* Basic Books, 2007.

Holt, Douglas B. *How Brands Become Icons: the Principals of Cultural Branding.* Harvard Business School Press, 2004.

Jones, John Philip. *What's In a Name? Advertising and the Concept of Brands.* Lexington Books, 1986.

Klein, Naomi. *No Logo: Taking Aim at the Brand Bullies.* Picador, 1999.

Kumar, Nirmalya. *Marketing as Strategy: Understanding the CEO's Agenda for Driving Growth and Innovation.* Harvard Business School Press, 2007.

Kurlansky, Mark. *1968: The Year that Rocked the World.* Ballantine Books, 2004.

Linklater, Richard. *Slaker.* St. Martins Press, 1992.

Liszka, James Jakob. *The Semiotic of Myth: A Critical Study of the Symbol.* Indiana University Press, 1998.

Mark, Margaret, and Carol S. Pearson. *The Hero and the Outlaw: Building Extraordinary Brands Through the Power of Archetypes.* McGraw Hill, 2001.

Moog, Carol. *Are They Selling Her Lips? Advertising and Identity.* William Morrow, 1990.

Ogilvy, David. *Ogilvy On Advertising.* Crown Publishers, 1983.

Olins, Wally. *Corporate Identity: Making Business Strategy Visible Through Design.* Thames and Hudson, 1989.

Olins, Wally. *The Corporate Personality: An Inquiry Into the Nature of Corporate Identity.* Mayflower Books, 1978.

Penn, Mark J. *Microtrends: The Small Changes Behind Tomorrow's Big Changes.* Hachett Book Group, 2007.

Pine, Joseph B. *Mass Customization: The New Frontier in Business Competition.* Harvard Business School Press, 1994.

Popcorn, Faith. *Clicking: 16 Trends to Future Fit Your Life, Your Work, and Your Business.* Thorsons, 1996.

Rapaille, Clotaire. *The Culture Code: An Ingenious Way to Understand Why People Around the World Live and Buy as They Do.* Broadway Books, 2006.

Schlosser, Eric. *Fast Food Nation: What the All-American Meal Is Doing to the World.* Penguin Press, 2001.

Underhill, Paco. *Why We Buy: The Science of Shopping.* Orion Business books, 1999.

Wunderman, Lester. *Being Direct: Making Advertising Pay.* Direct Marketing Association, 2004.

Zaltman, Gerald. *How Customers Think: Essential Insights Into the Mind of the Market.* Harvard Business School Press, 2003.

About the Author

Mac Cato has a fifty-year perspective on global branding. He was the principal founder of Cato Johnson, a global creative marketing firm that was acquired by Y&R in 1975 and later merged as Wunderman Cato Johnson. Wunderman is now one of the world's foremost Consumer Relationship Marketing agencies. He also started Cato Gobé and helped build Desgrippes Cato Gobé (renamed DG upon his departure). He is currently a partner in Cato Associates and Cato Dangoor, balancing consultancy with teaching and writing. He helped to shape the evolution of emotional branding into a primary creative tool used in developing global brands. This book reflects history, personal and societal, and the dramatic impact of the profound changes confronting our globalized world today. Cato posits that the increasing convergence of commercial persuasion and societal persuasion branding will be a critical factor in restoring global confidence in sustainable economic growth—in direct contrast to the negative thesis offered by Naomi Klein in her books *No Logo* and *Shock Doctrine*.